YOSHITAKA AMANO
ILLUSTRATIONS

Contents

FINAL FANTASY

Any survey of Yoshitaka Amano's art must include his work on *Final Fantasy*. Having been involved with the artistic design of the series beginning with the very first game, he has played an essential role in the creation of its epic world. The series quickly became a global hit and is now one of the most important and influential video games of all time.

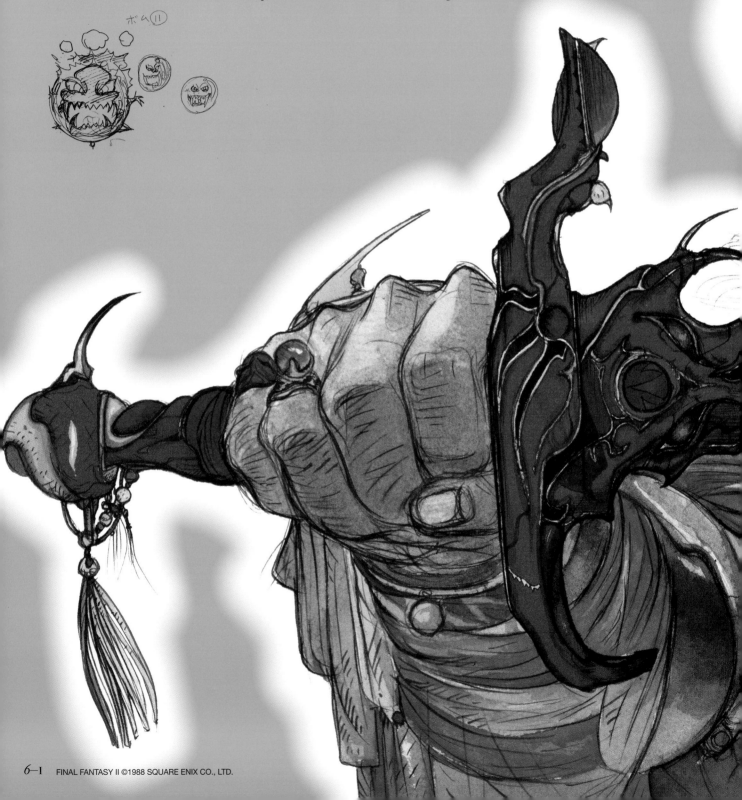

FINAL FANTASY II ©1988 SQUARE ENIX CO., LTD.

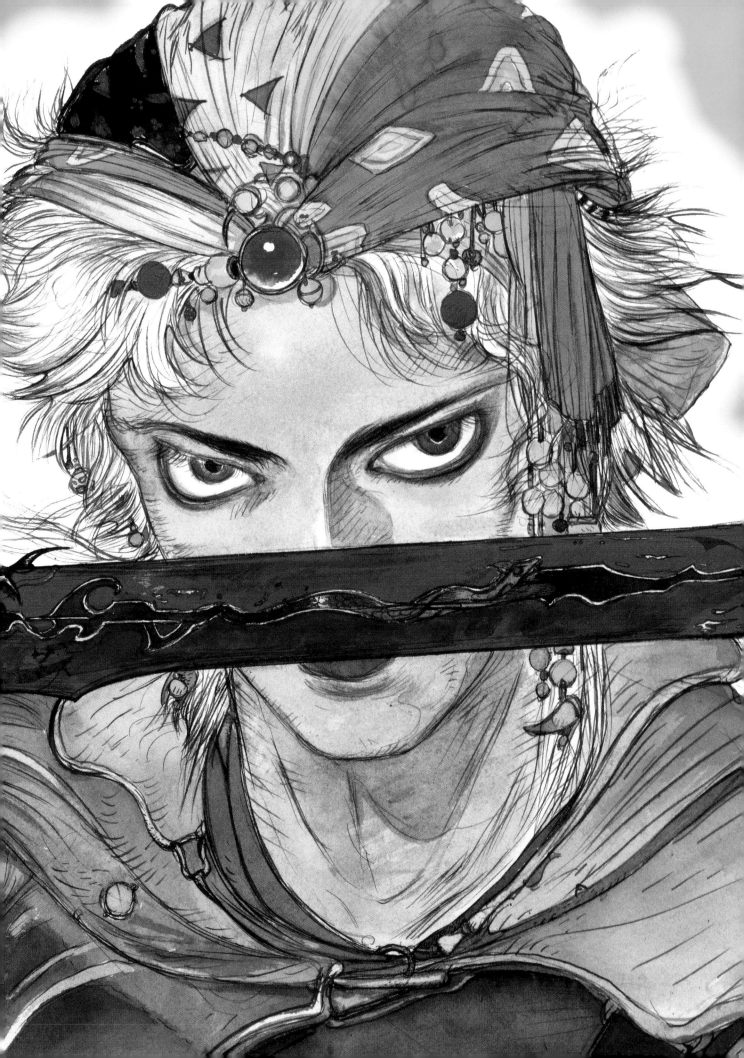

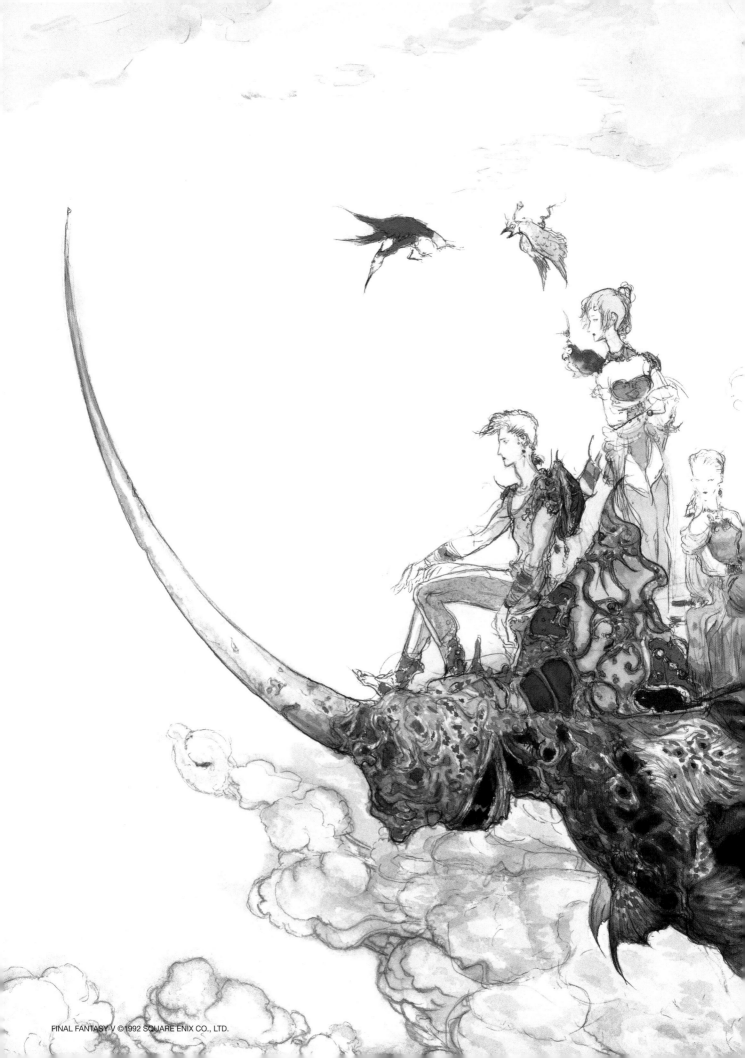

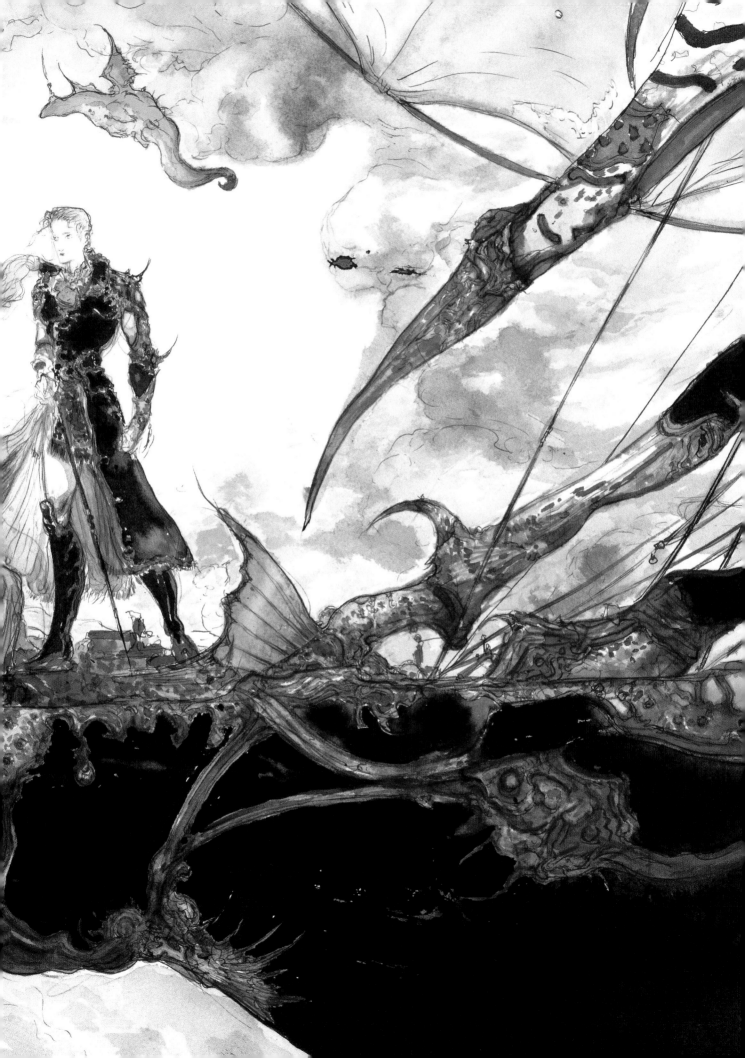

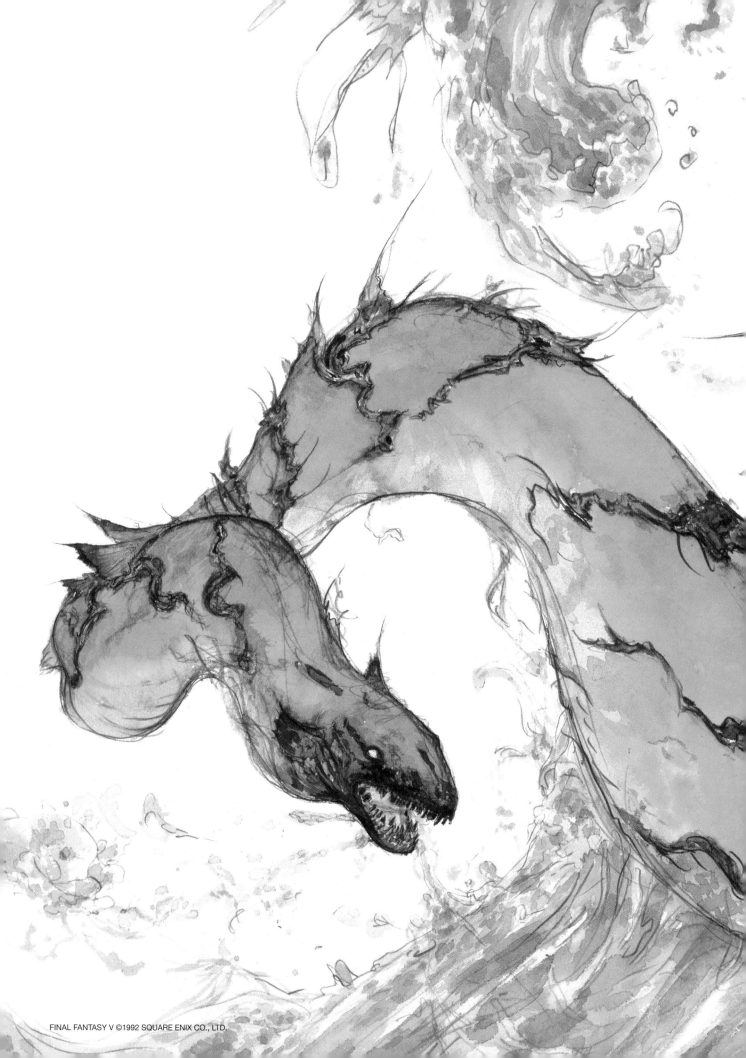

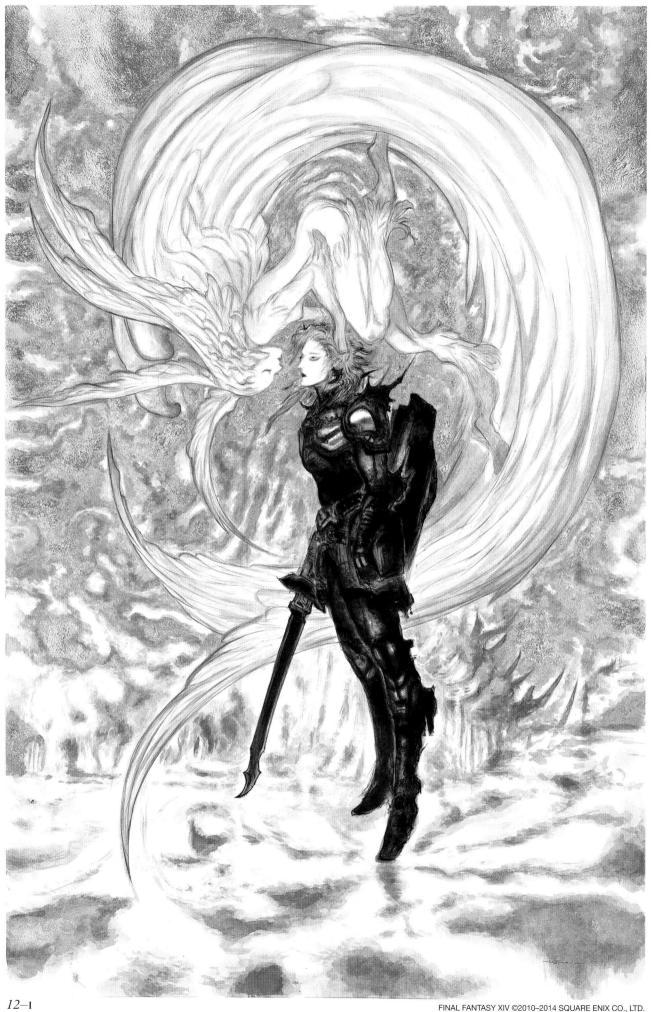

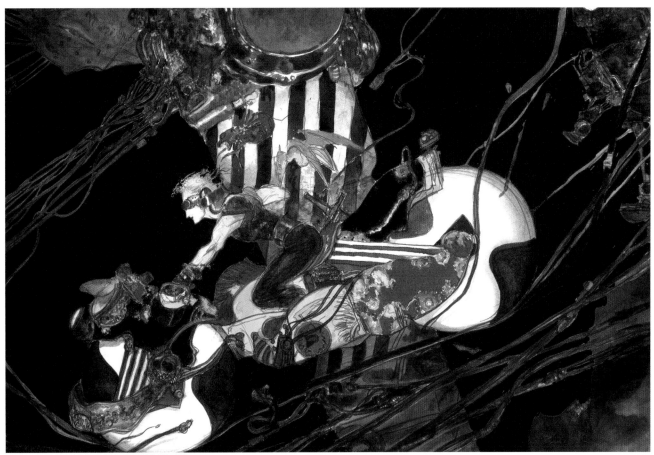

FINAL FANTASY VII ©1997 SQUARE ENIX CO., LTD.

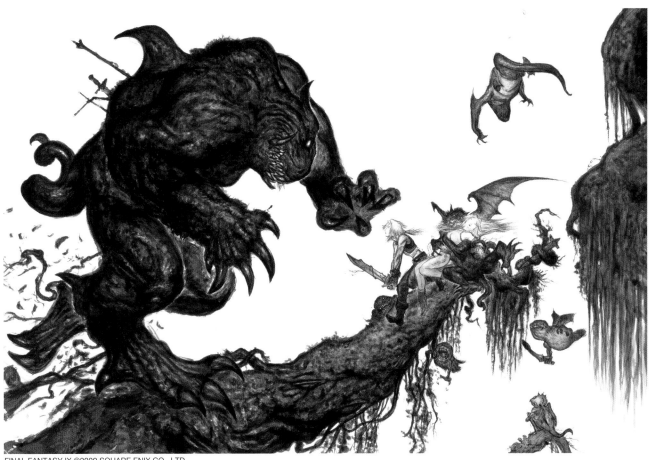

FINAL FANTASY IX ©2000 SQUARE ENIX CO., LTD.

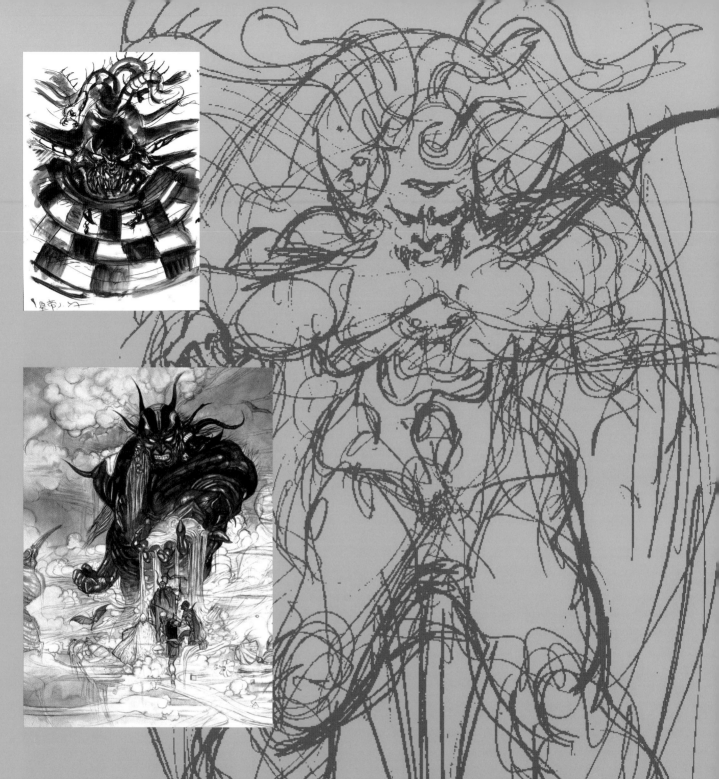

AMANO ON FINAL FANTASY

I received the offer to work on it around the time *Dragon Quest* came out and the genre of role-playing games was just starting to gain popularity. At that time, my preconception of video games was basically things like *Space Invaders*, but I decided to accept the *Final Fantasy* offer after learning that the visual aspect would be very important to the game, which I felt was a compelling reason for me to take on the job.

Back then, because computers didn't have that much processing power, video game characters were pixelated

and not finely rendered. So I wanted players to be able to imagine the world of *Final Fantasy* by looking at my artwork.

I start working on the illustrations after getting creative briefs on the story and character settings. I'm involved with a game only at the very initial stages, however, so the world and settings continue to change even after the developers see my concept designs. I've continued to work that way since the first game, twenty-seven years ago.

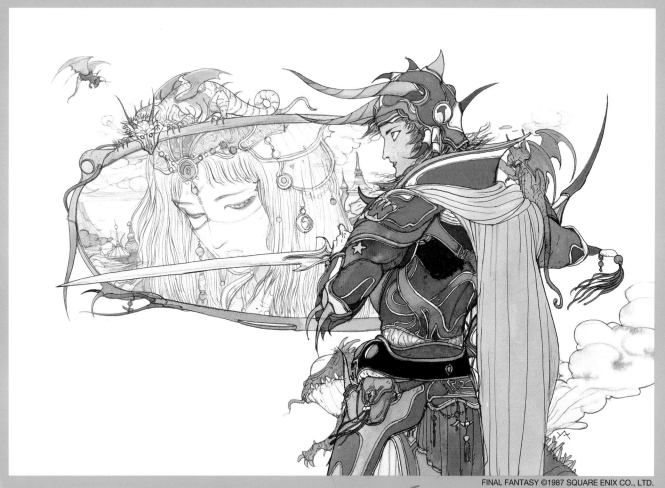

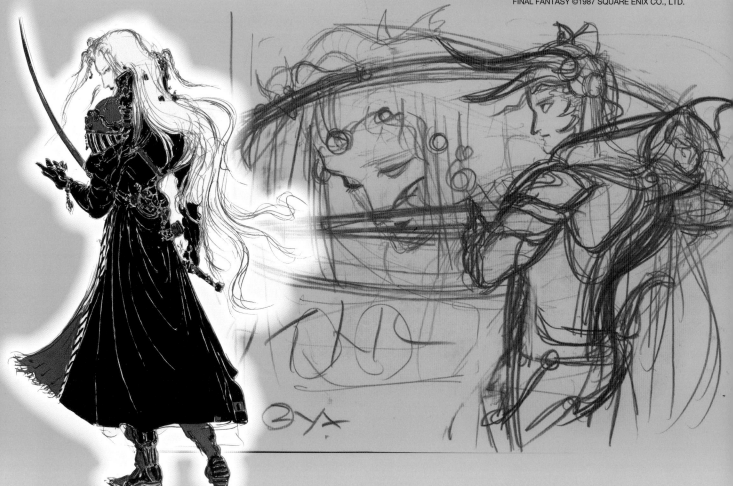

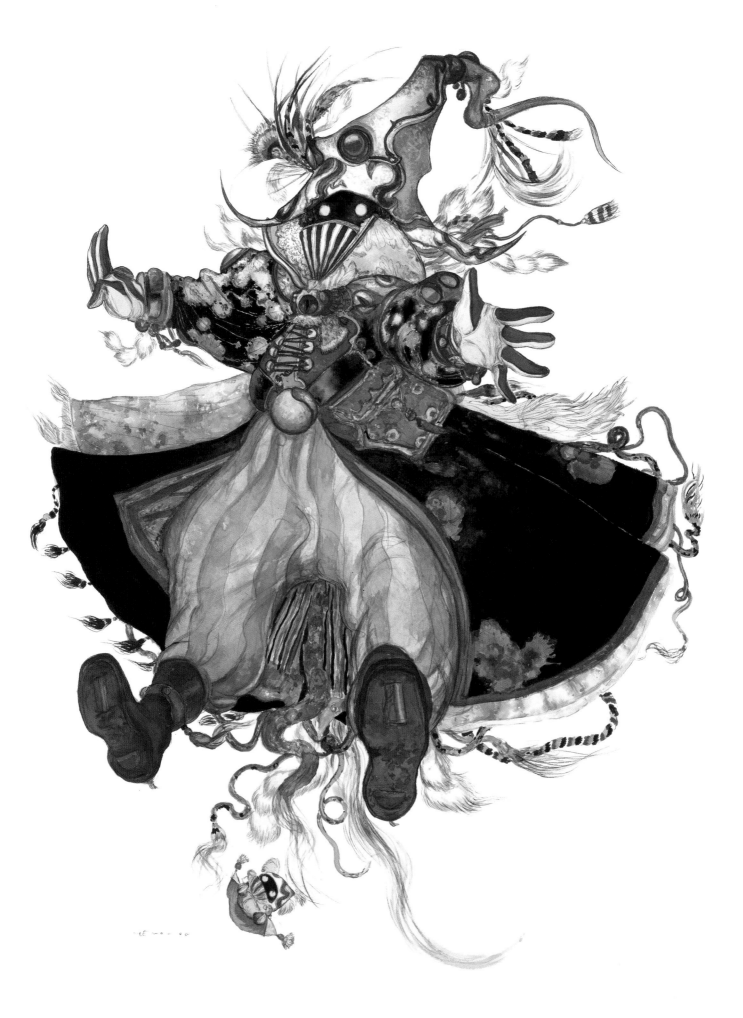

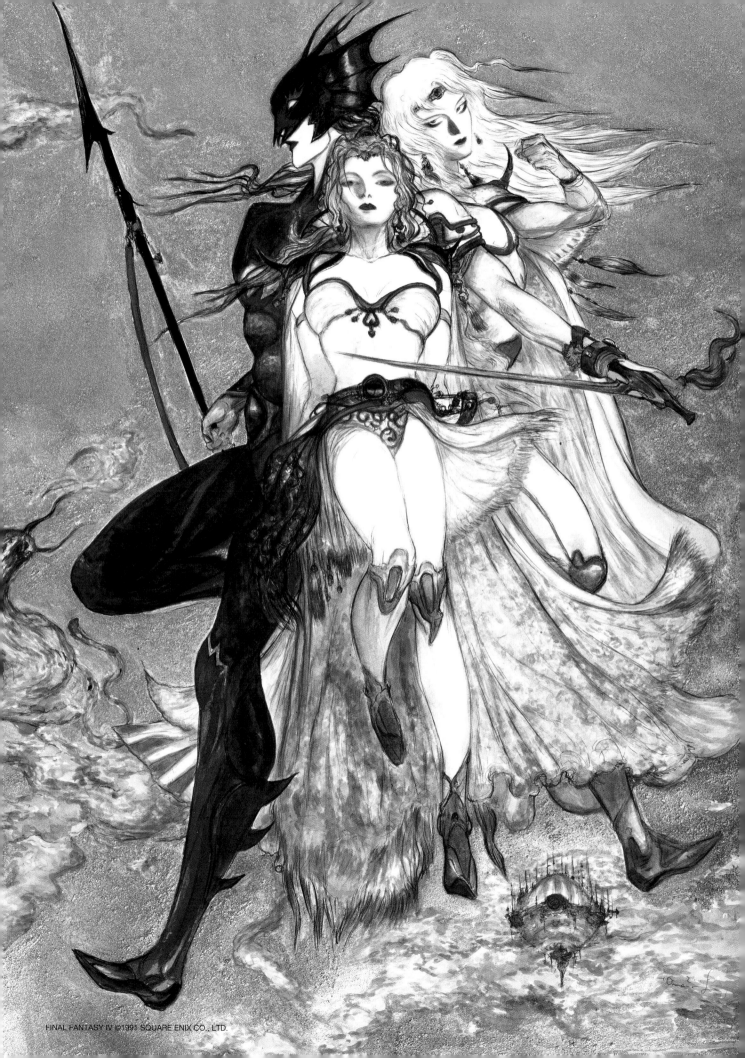

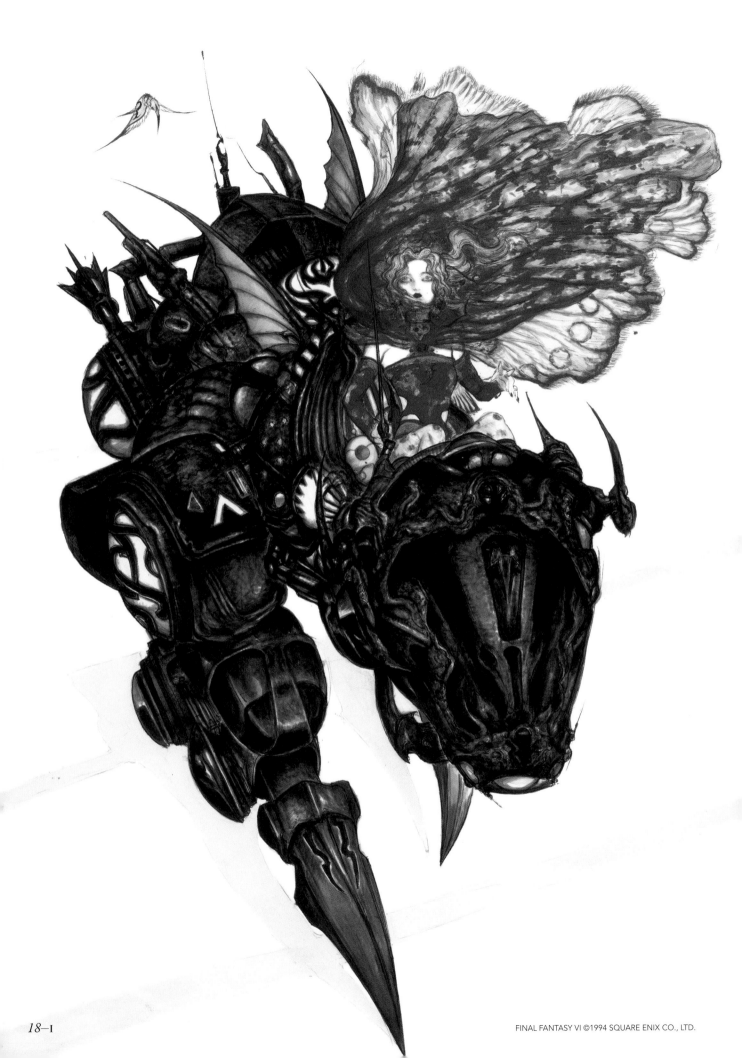

18–I

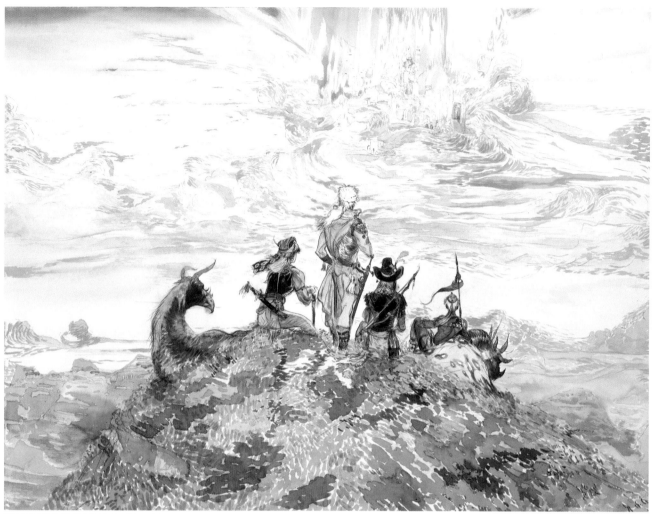

FINAL FANTASY III ©1990 SQUARE ENIX CO., LTD.

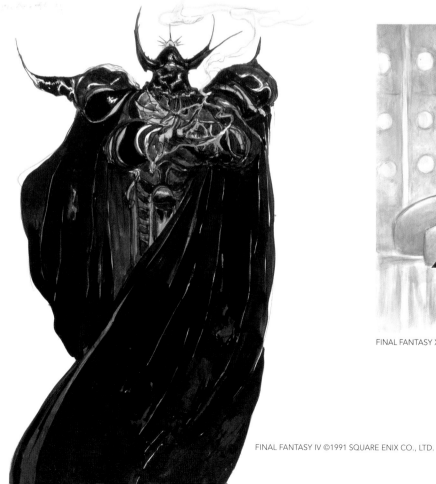

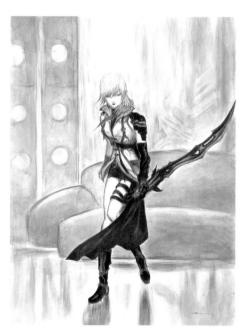

FINAL FANTASY XIII ©2009, 2010 SQUARE ENIX CO., LTD.

FINAL FANTASY IV ©1991 SQUARE ENIX CO., LTD.

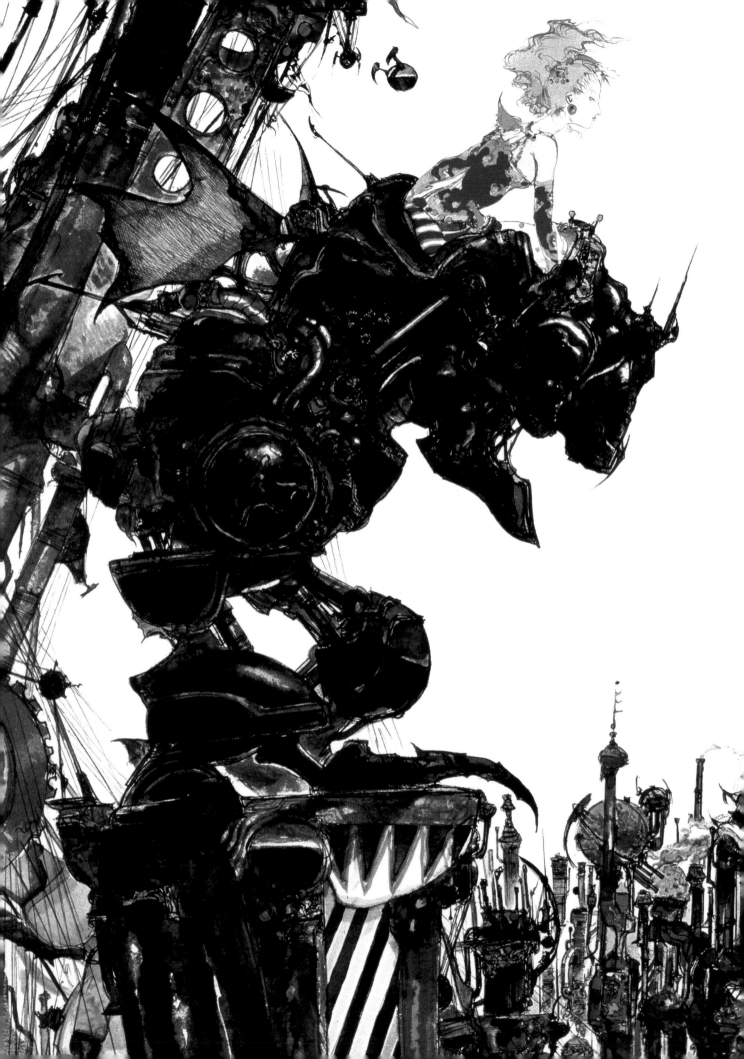

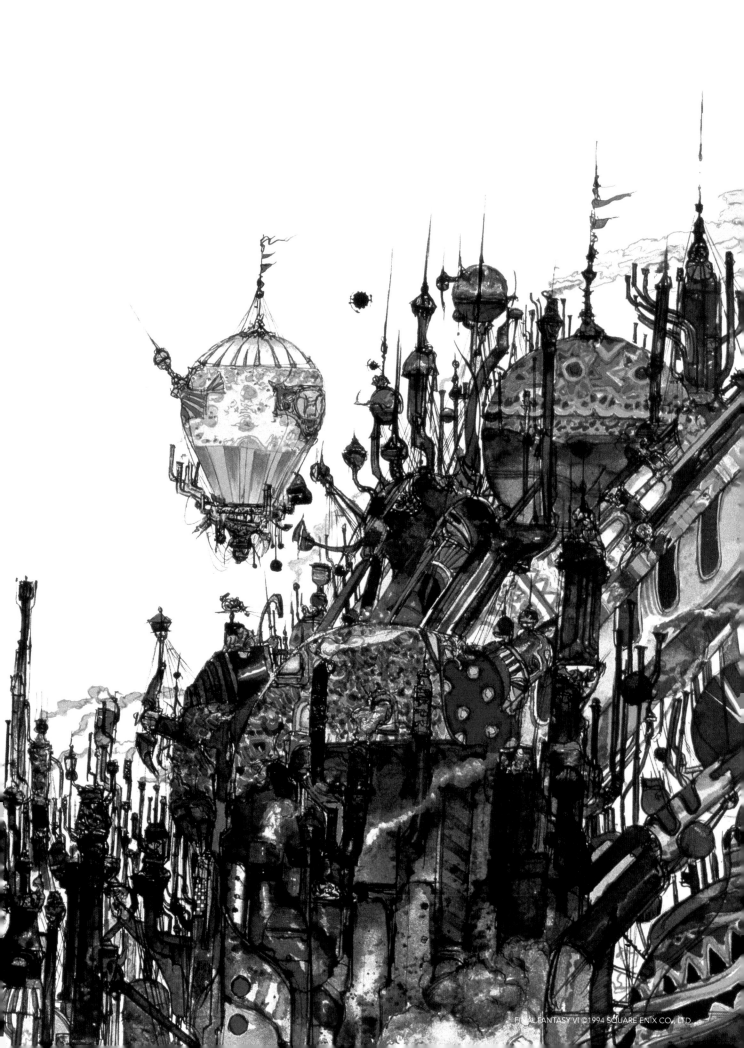

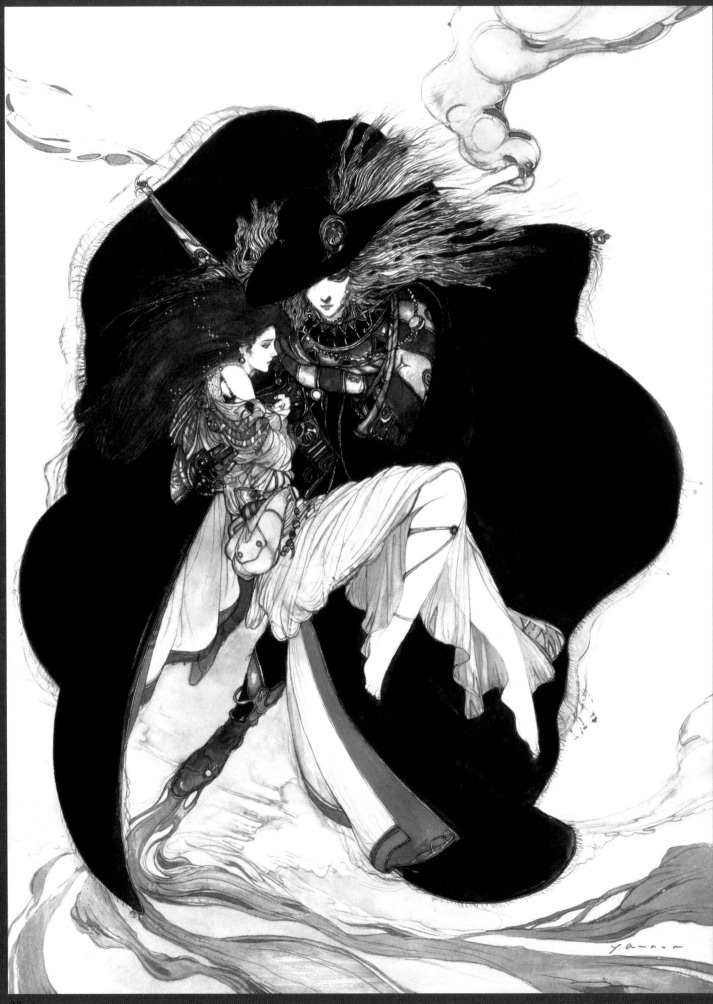

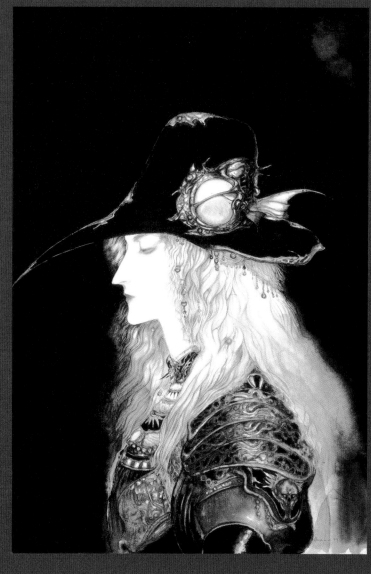

Cover Illustrations

Yoshitaka Amano has created cover illustrations for many best-selling novels, including the *Vampire Hunter D* series, which he began doing the artwork for in 1983. Amano's outstanding work has helped draw reader attention to a number of series, among which are the four prominent ones covered here.

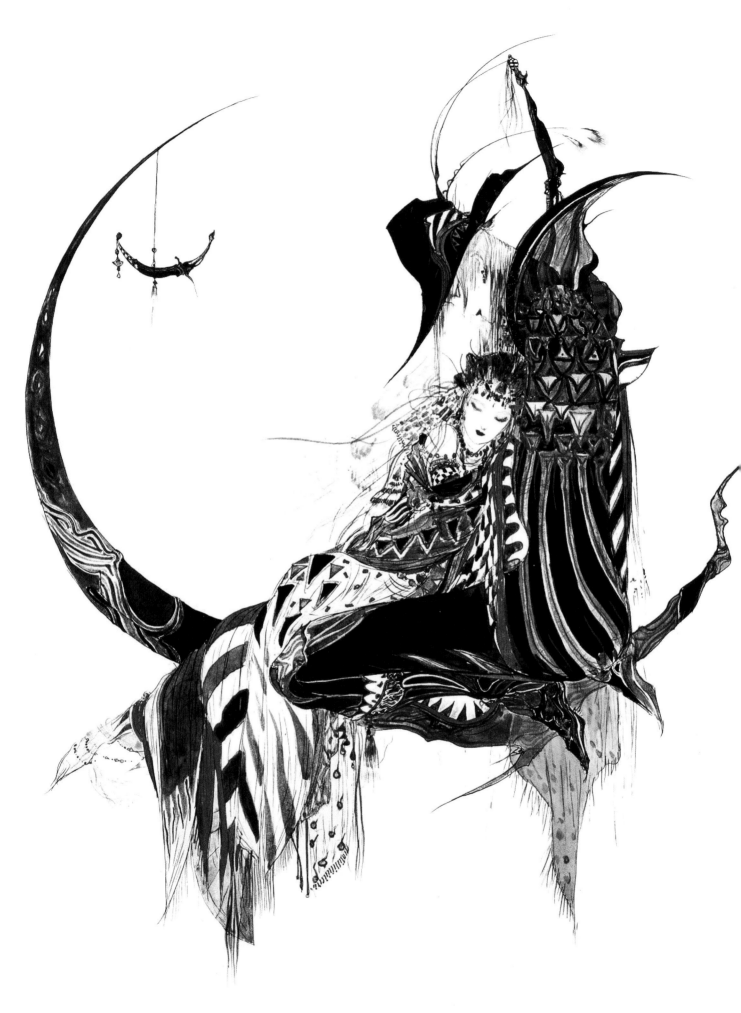

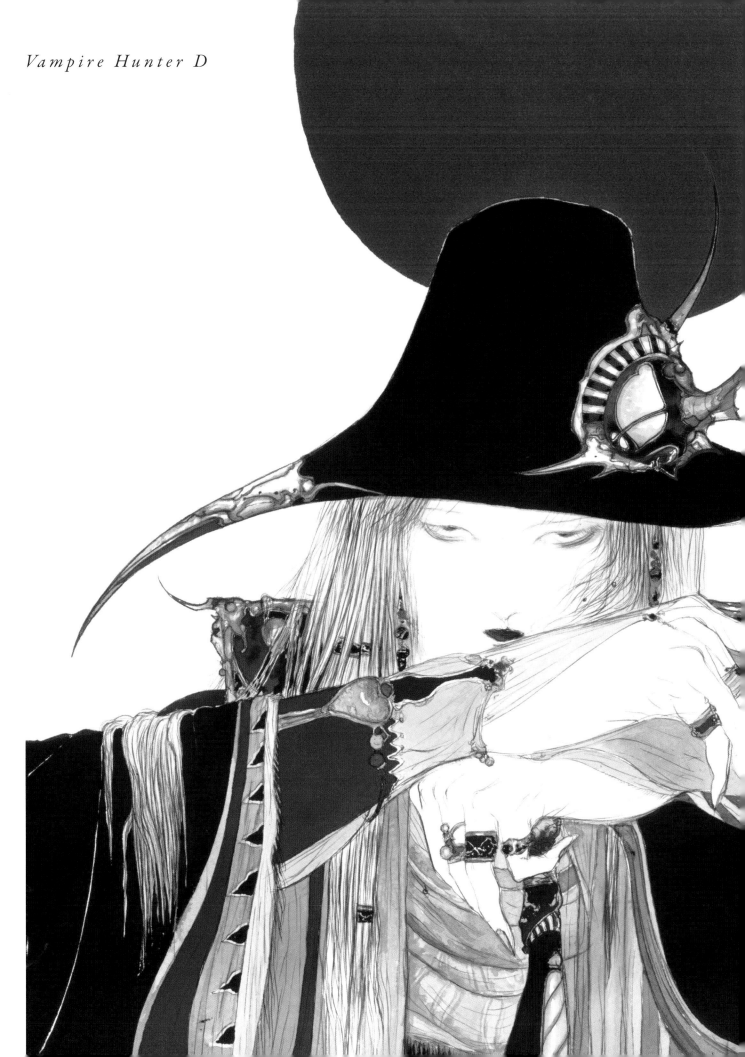

Vampire Hunter D

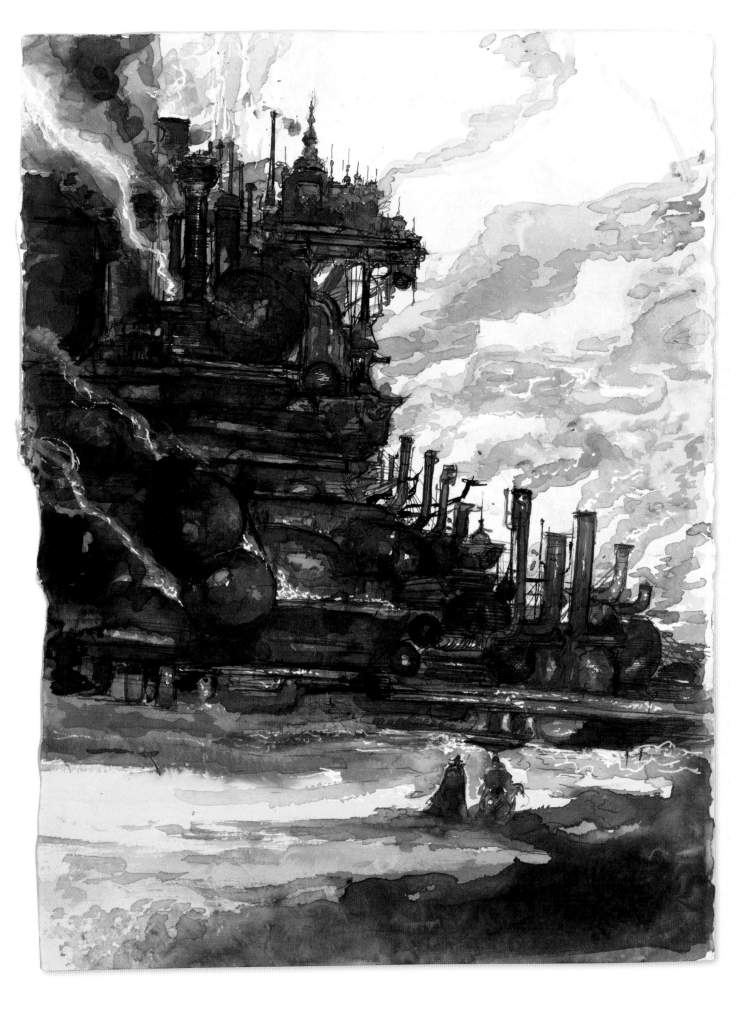

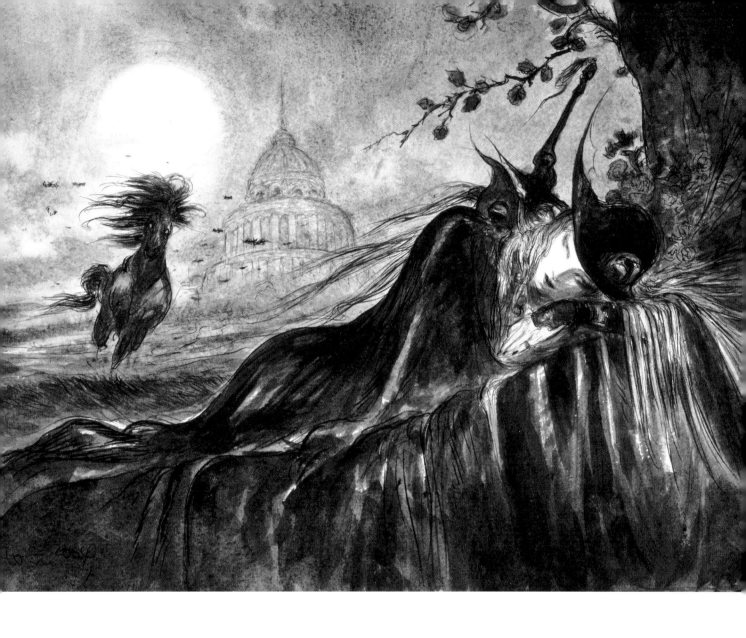

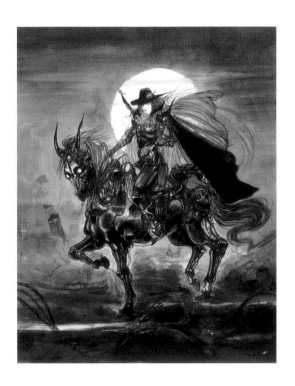

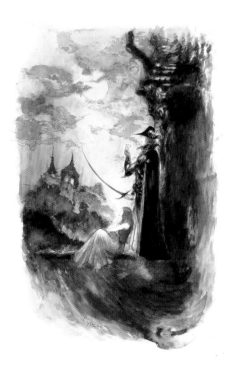

*Vampire Hunter D
The Festival of Nobility*
By Hideyuki Kikuchi
(Asahi Shimbun
Publications Inc., 2014)

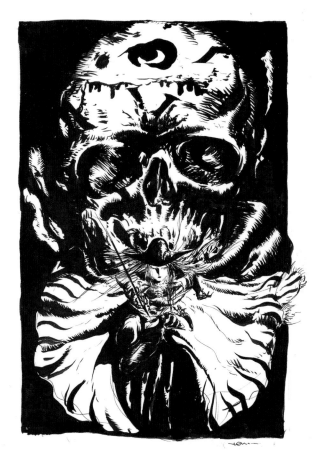
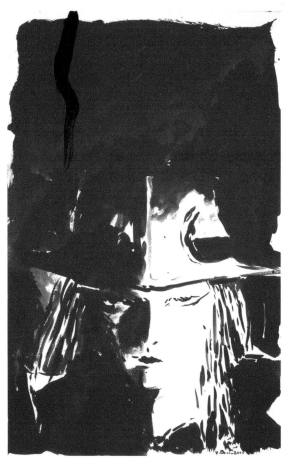

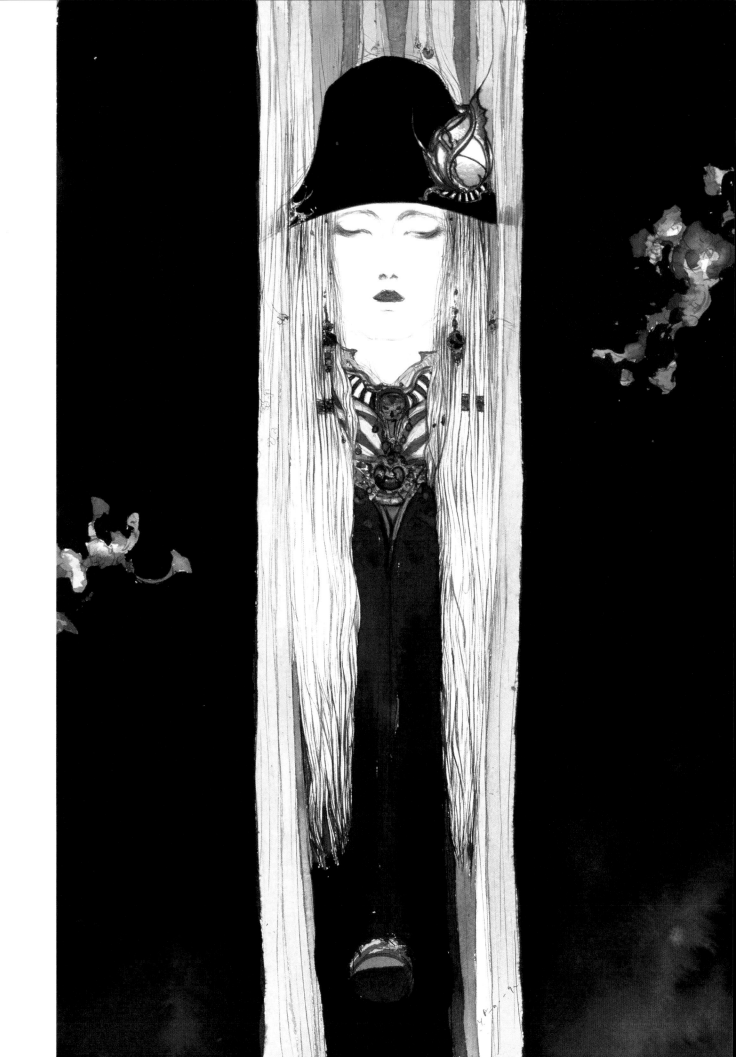

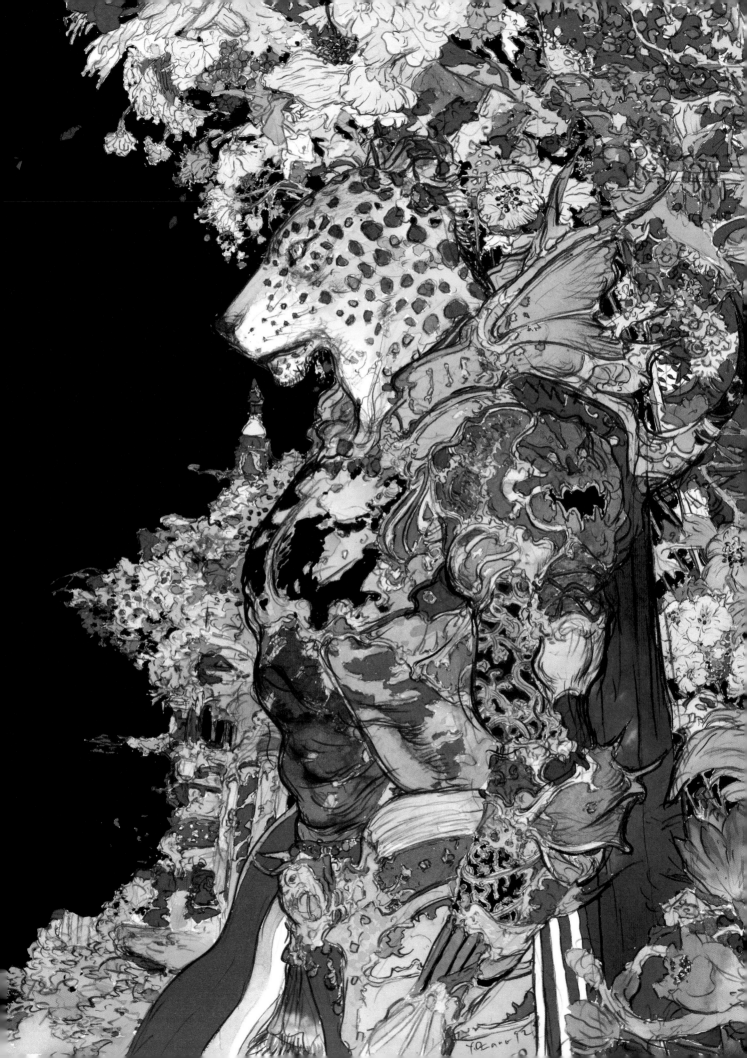

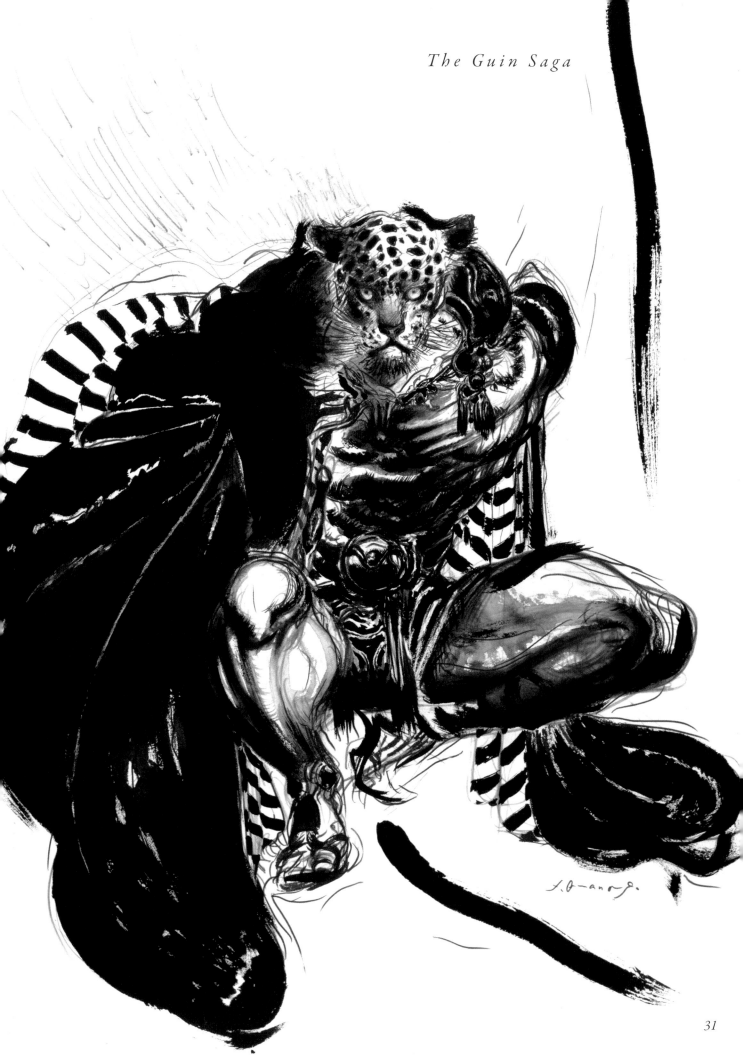

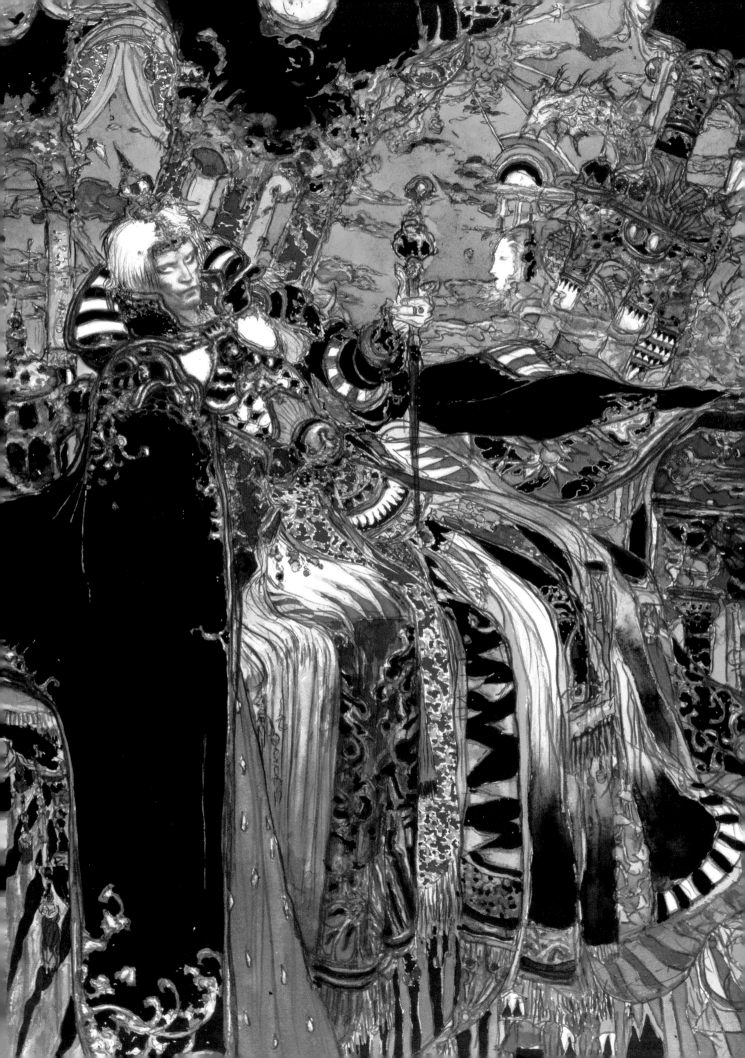

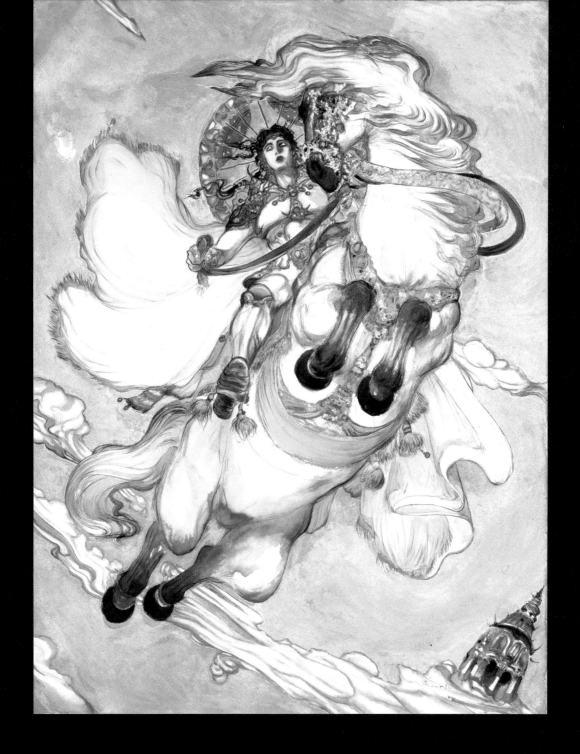

AMANO ON COVER ILLUSTRATIONS

When I'm working on a book cover, I have to consider where the title text will be placed, but other than that I just draw what I want. It's fun to be an early reader of a novel, to illustrate the world that the author created and have it appear on the cover of the book. In the past I used to work as a professional illustrator; I enjoyed reading stories and brainstorming on the composition and colors of the pieces.

And I learned a lot from those jobs.

As an artist, I think of a cover illustration as another place to exhibit my artwork. A book with a cover I worked on will be displayed at every bookstore around the country, so it presents a very attractive opportunity for me to get my art out there.

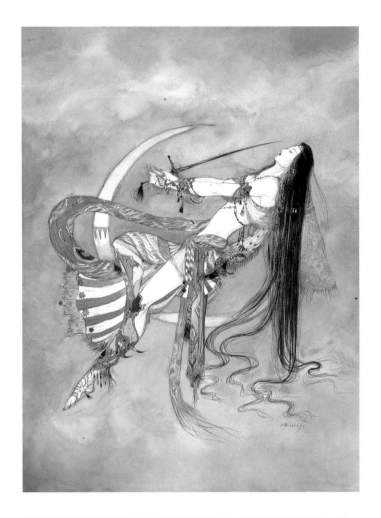

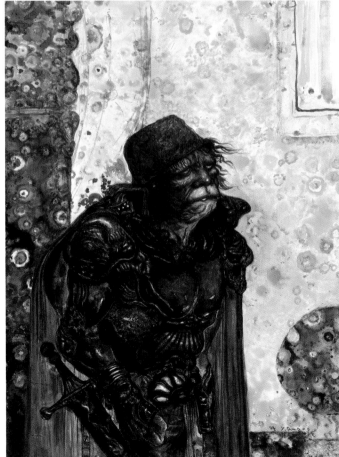

The Guin Saga, vol. 23
Whereabouts of the Wind
By Kaoru Kurimoto
(Hayakawa Publishing, Inc., 1985)

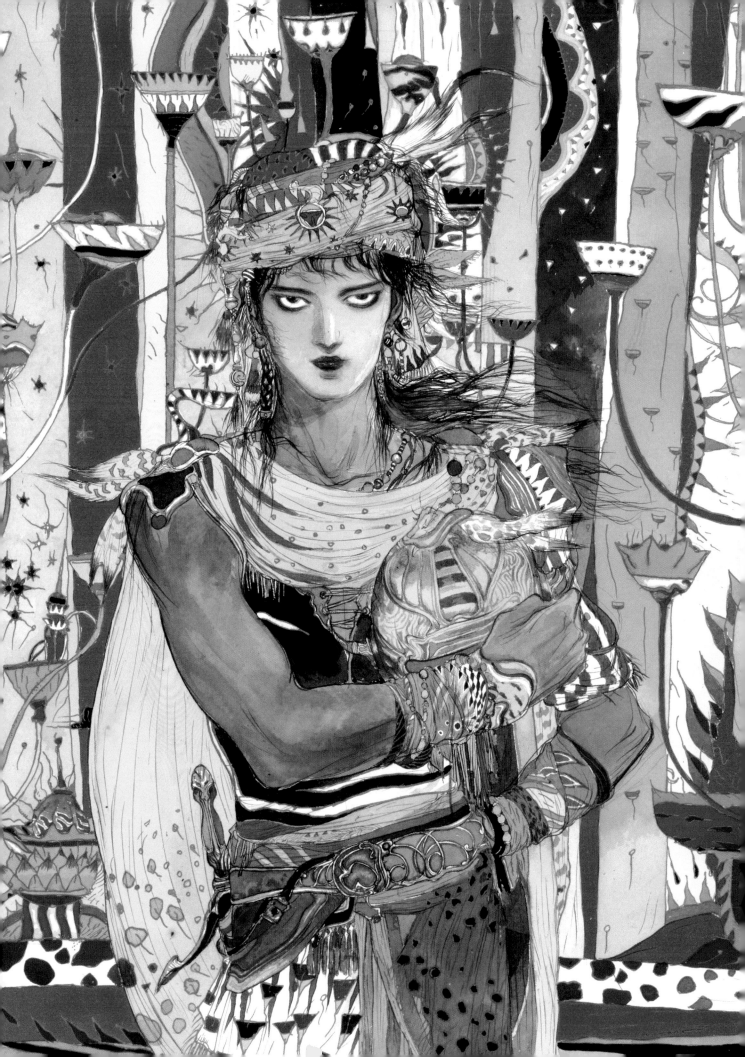

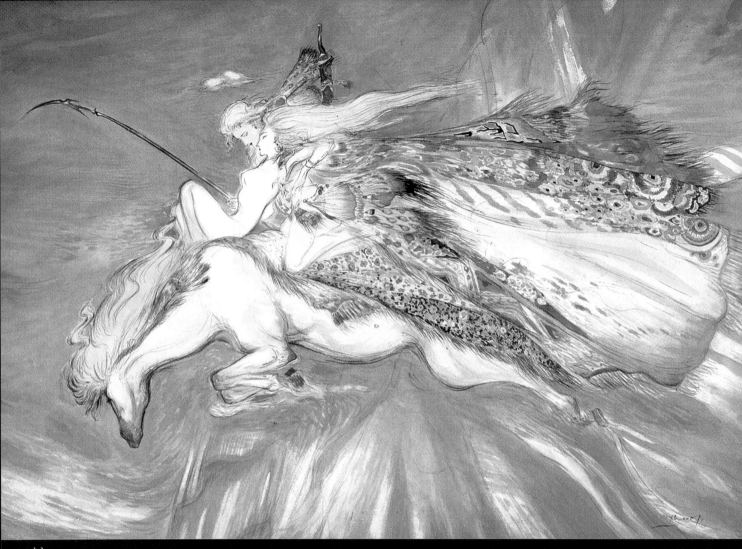

The Heroic Legend of Arslan, vol. 1
The Royal Capital Burns
By Yoshiki Tanaka
(Kadokawa Shoten Co., Ltd., 1986)

The Heroic Legend of Arslan

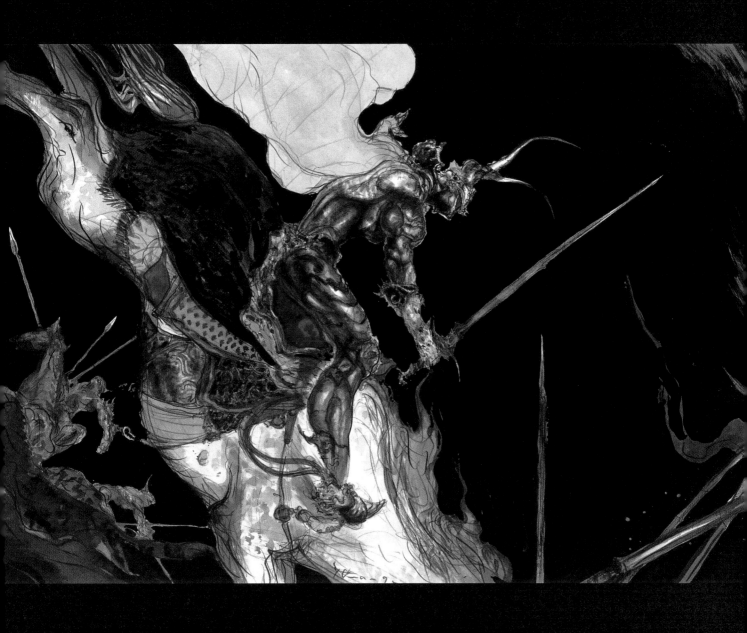

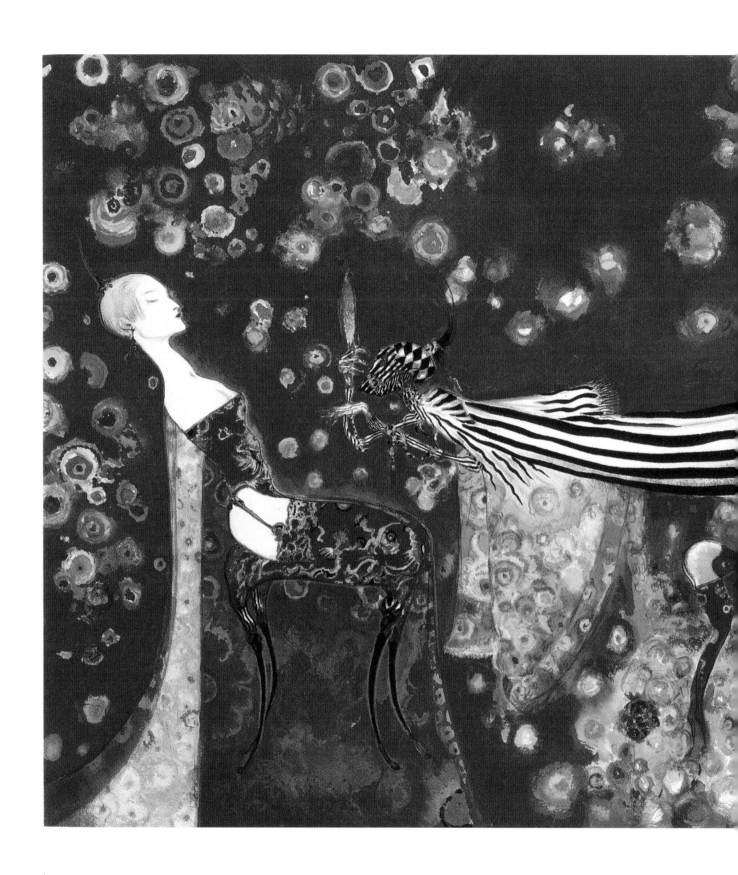

Edogawa Rampo

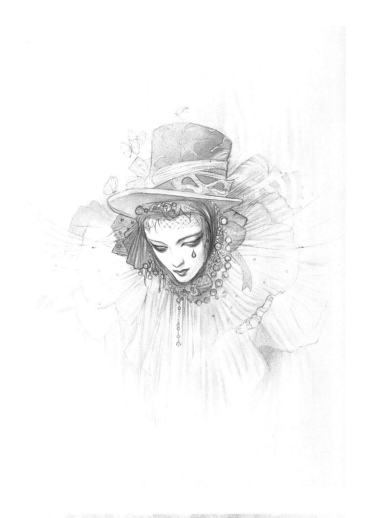

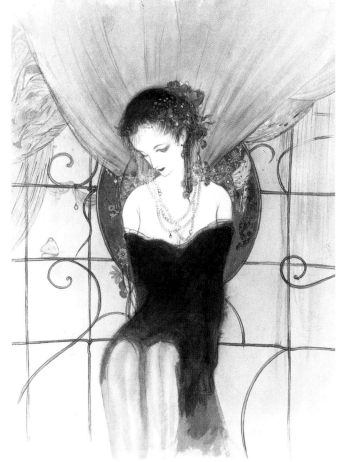

From left:
The Fiend with 20 Faces /
Junior Detective League,
Beast in the Shadows,
Two-sen Copper Coin
By Edogawa Rampo
(Kodansha Ltd., 1987)

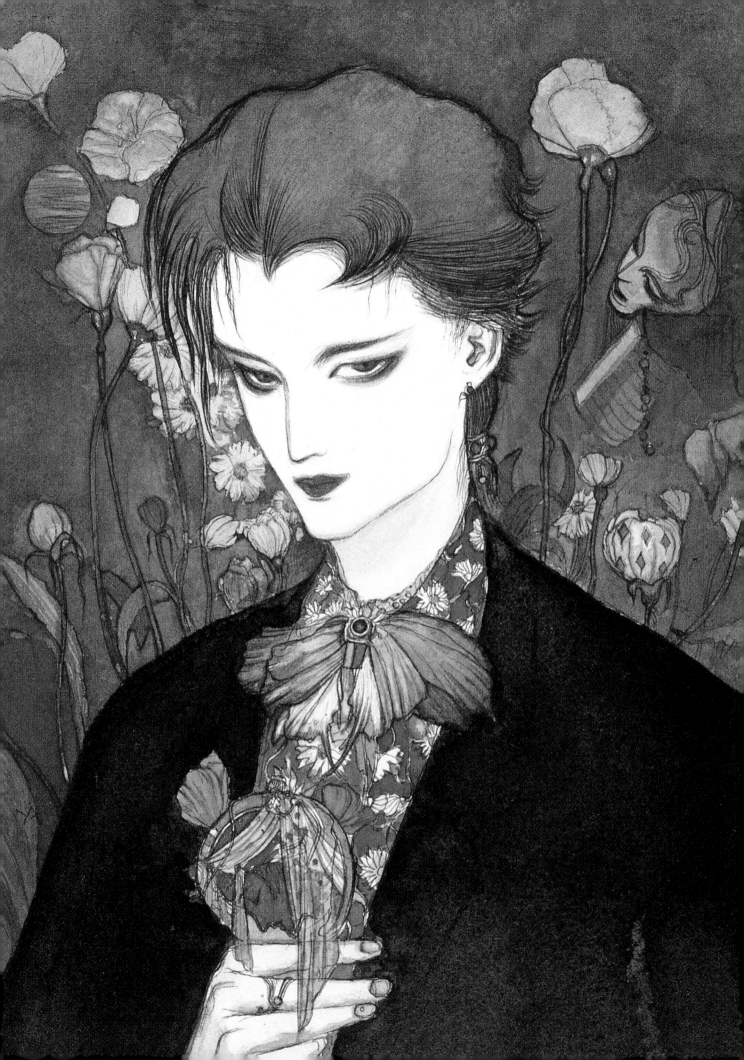

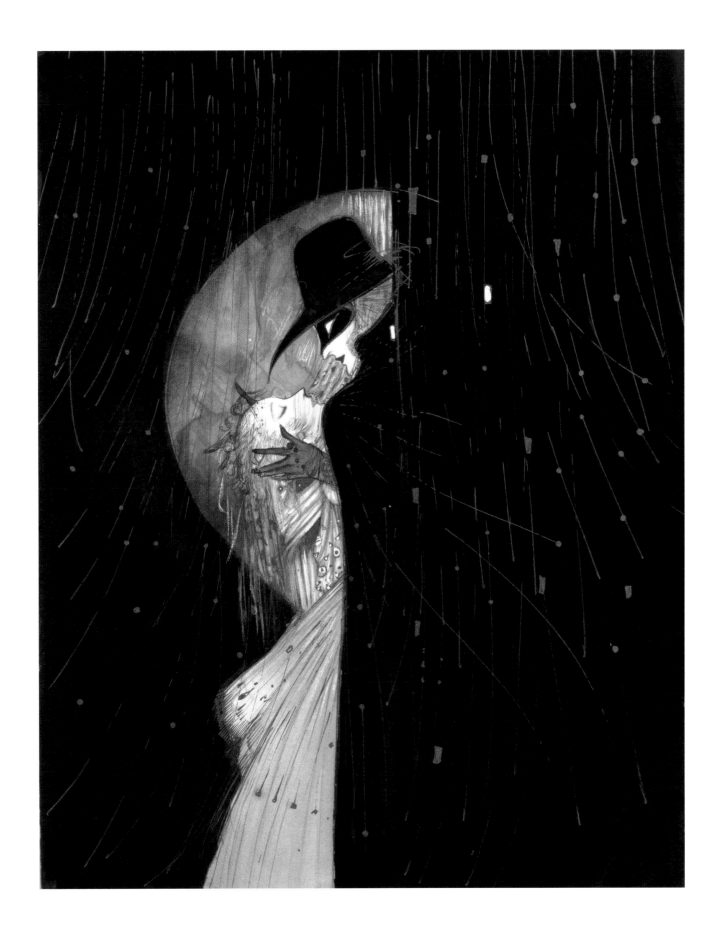

INTERVIEW *with* AKIRA UNO

A Conversation Between
Two Graphic Arts Masters

This meeting came about through Amano's wish to have a conversation session with the graphic artist Akira Uno. The two of them had worked together around thirty years ago with Amano as an illustrator and Uno as art director. The conversation starts off as Uno looks through Amano's book *N.Y. Salad*.

ON VEGETABLES AND SKETCHES

Uno: This is so cute. The blue color is lovely. It's rare for a character in a children's book to have such a blue face.

Amano: I guess so [laughs]. It's a lithograph.

U: Really? How did you pull off the color gradations?

A: I used a roller. Actually, I should say a roller was used; it's not like I did the actual printing.

U: Color gradations using a roller.

A: Yes, I asked the printer to do it for me.

U: There was a technique that Tadanori Yoko discovered with silk screen where you place different colors on either end of the roller, merge them together, and then roll out the resulting blend.

A: I think it's the same technique.

U: This is a very delicate piece of work. The shading over here is nice too.

A: I didn't want to outsource this to another art studio. Instead, I set up a lithograph workshop inside my atelier and had them work there every day.

U: Good idea.

A: And to be honest, I didn't consider this project to be work. I would play with it when I had some free time on my hands in between my "real" work sessions. The pieces accumulated over the course of time, and eventually my manager wanted to compile and release them, so we decided to publish them as a picture book.

U: If you have a lithograph workshop inside your studio, you don't have to worry about the editor coming back to you and saying, "We'd like to change this like so," and then having to send your work out to the printers again.

A: Exactly. When I was creating these pieces, I had no intention of publishing them. I just had some free time on my hands while I

was living in New York, so I used that time to draw little sketches, and the sketches piled up, and eventually they turned into a picture book.

U: The characters are so cute.

A: They're my own imaginary characters, but they're all based upon real vegetables.

U: The details are amazing.

A: I don't do pencil sketches that often, so I used them as an opportunity to train myself.

U: I see.

A: And I decided to draw odd little vegetables because I thought it wouldn't be any fun if I did just ordinary sketches.

U: You refrained from adding any red shading to their skin tones. I think that's cool.

A: Yes, and I probably would have if I were using paint. But because I was restricted by the materials I was using, it turned out nicely different.

U: Sometimes you can go too far in that direction, though.

A: Right. When you do, something can end up being too rich. Like the difference between an original illustration and a woodblock print.

U: Even the photos in *N.Y. Salad*[1] are stylish.

A: This was before Dean & Deluca came to Japan. At that time, it was just one shop down in Soho. And not only was the shop fancy, but the vegetables they sold were fancy too. I thought, "Hey, this is something you don't see in a Japanese supermarket."

(1)

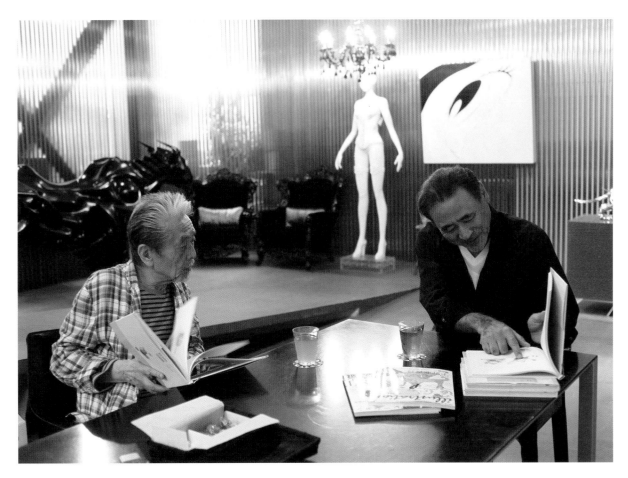

U: I can tell how different it is from Japan by looking at the photos.

A: They had many types of vegetables that I had never even seen before. Even the melons were very small and cute.

U: Nowadays we have these vegetables in Japan too, but the way they're displayed is very different.

A: That's right. The displays are so cool. It's just not done the same way in Japan.

U: What's this bottle?

A: That's olive oil.

U: What a perfectly shaped, delicate little bottle.

A: Very fancy.

U: The Japanese bottles are too big. Small bottles that you can empty after a few uses are enough, I think.

I DIDN'T HAVE MY OWN ART

U: I have only a rough knowledge of your professional history, but you worked for the animation studio Tatsunoko Production, right?

A: That's right.

U: How about before that?

A: I started at Tatsunoko when I was just fifteen years old, so there was nothing before that. I worked as a character designer at Tatsunoko Pro, doing initial creative work for the animators. Basically, the animators would use my designs for inspiration when creating the actual animations that would appear on TV, so my work hardly ever made out it out into the world. I only ever worked like that while I was at Tatsunoko.

U: When you were coming up with the character designs, were you given specific directions like, "We want the character to have a personality like this," or "We want the character to look like this"?

A: No, the animations created by Tatsunoko Pro were original series and not based off other works, so I never received requests like that from the outside. We all created the properties together, asking each other "How about this?" or "What about this?" And whenever we got to a point where we were really stuck, then the people in the Planning Department would lock themselves in a hotel room to hash out the story.

Those of us doing the artwork then would have to design the characters based upon the rough outlines and personas that were set in the story, so we'd shut ourselves away in an inn to draw them. And in the end we'd all bring together everything we prepared, assemble our project out of that, and take it down to the TV station. So our company literally created everything from scratch.

U: I feel that you already had the base of your personal art style when we worked together. It was different from your character design work at Tatsunoko, but even those designs contained glimpses of your current style.

A: I used to believe that I didn't have my own art because I had been working for an animation production company on their properties, not on my own.

U: But you've definitely got it now.

A: I went through a lot of trouble to find it. It came through the efforts of working as an illustrator, when I decided I wanted to create my own work, to be exact. Until then, I had always been given themes to work on, so what was I supposed to do when I wasn't given any direction? That was when I began to draw inspiration from other artists. I'd copy the style of artists I liked. That's why there was a time when my artwork had an art nouveau feel to it.

THE SEARCH FOR MY OWN ART

U: I think I remember seeing a lot of classical-style artwork from you when I was asked to design the cover for a Shinshokan publication.

A: It's because Shinshokan used to publish a lot of books on opera and ballet. After that, I asked you to work as the art director for my book *Genmukyu* (Castle of Illusions).

U: Right. Shinshokan was specializing in books on opera back then.

A: At the time, I was into drawing story illustrations. I felt that I wouldn't be able to give a piece depth if I just created whatever I wanted to create. So I thought I could gain more experience by reading a story and illustrating it.

U: For that you had a text or story to work from, but it wasn't like you concentrated on background research to create something authentic. Still, I think you already had your own distinct style back then.

A: That was something I couldn't really see myself. I think I was influenced by many people and only gradually began to get a grasp of my own art style. Even though I was developing my own style, I was still working under the idea of creating an illustration that fit the story.

U: This illustration[2] is done completely in red. I remember you doing works like this when I hired you to create pieces for me.

A: Right.

U: You draw monochrome illustrations but then you also suddenly do very colorful ones too.

A: I like classical-looking illustrations, but then I start having the urge to use color after a while.

U: You've got full command of a lot of techniques, don't you? I find this piece[3] very interesting.

(2)

(3)

©Tatsunoko Production

A: That's silk.

U: Silk screen. It has a Warhol-like feel to it.

A: That's true, it was was greatly influenced by Warhol.

U: But the subject is different.

A: Warhol drew actual people, but I decided to draw a character I created.

U: Right. Warhol used famous people as his motif but you'd already created famous characters like that yourself.

A: If I used someone else's character, I'd end up with something different than what I intended. I wanted to express my history in pop art style by using a character I created or was involved in creating.

U: What kind of words are used the most to describe your style? "Aesthetic" is a term I see frequently. And I guess "fantasy" and "mysterious" are used often too.

A: I'm very incoherent [laughs].

U: "Gorgeous" would probably be another good term. I look at your work and the colors and textures are just wonderful. Also, you seem able to draw any pose or posture well, and that's amazing.

A: I've been influenced by you too, you know.

U: Really?

(4)

A: Of course. I used to read *illustration*[4] magazine all the time. And what I took away from reading it was that the world of illustration and the world of animation were totally different. Back then I used to think that illustration work was superior, but animation was my job, so I was always sulky about it. I wanted to create posters, and although I was given the opportunity to do so, they were posters for the animations I had worked on. That was during the '70s, when the works of Warhol, Peter Max, and other pop culture artists were being introduced into Japan. Even though I was a character designer, I tried to incorporate that pop essence into my work.

U: In the late '60s, there'd be dedicated poster shops in places like Shinjuku, and posters were a medium that captured everyone's attention. I'm not talking about the small B5 posters, but the large B1 sizes. It was a time when we were all strongly interested in theater posters and whatnot. These days displays don't call for large B1 posters, so even if you worked in the publicity division of a department store, say, you'd probably only get the chance to work on small posters. There aren't any spaces in the city to hang the large ones anymore.

That said, in terms of the nature of the work, working for a production company to create posters and being a freelance illustrator are the same thing. A playwright creates the world of a play, and for print publications there's the text. So I think they're all in the same group. But there was a time when posters seemed to be an extremely cool medium.

(5)

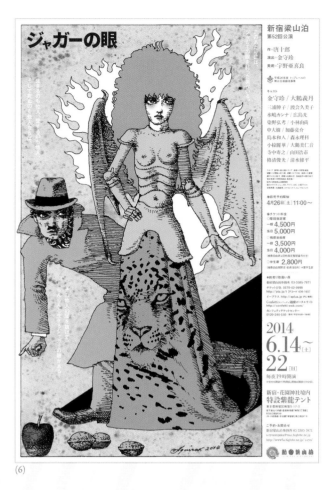

(6)

A: Right. I still get so excited just by looking at a poster with an Akira Uno illustration on it. Like the posters for Tenjo Sajiki [5]. You also did the poster for *The Jaguar's Eye* [6] recently, didn't you?

U: Ah, yes. I did one for *The Jaguar's Eye*.

A: When I see your theater posters I get that immediate kick of, "This is great!"

ON FINE ART

U: This one is very representative of your character design. Is it a recent work [7]?

A: Yes, it is.

U: You're such a good colorist.

A: Another example is this piece [8], which includes a lot of different elements.

U: Did you use a computer to do the colors for this one?

A: No, this is actually hand-painted.

U: Seriously? It's all done by hand?

A: Yes. It's a very large piece too, around two meters wide.

U: Did you use something like gouache or poster paint?

A: No, acrylic paint.

U: Acrylics. Amazing. Weren't you concerned that the colors would get muddy if you painted them on top of the blue background?

A: Actually, I did it the other way around. I did everything else first and then colored in the blue background at the very end.

U: So you basically left the background uncolored? That's impressive. It's not as simple as it sounds. You can't improvise at all while you're working that way, can you?

(8)

A: Right. The background was masked with painter's tape. And I drew the outlines in at the end for the finishing touches.

U: That's just like what Seiji Fujishiro does.

A: But I'm rather clumsy, so I had my assistant cut out the masking pieces from painter's tape.

U: Was this created as a stand-alone work of art?

A: Yes.

U: Then it's not tied to an animation or anything?

A: No. Don't you get bored when you have to keep drawing the same thing?

U: I do [laughs].

A: Every now and then I get the urge to draw something different. It's the same with the painting tools I use. I like creating works using different methods. And when I do, it's extremely refreshing. It feels like I'm going back to my roots.

U: That's your strong point. You enjoy drawing all over the place. But not many people can do that. You know, they get thrown off by irregularities and unexpected results.

A: Speaking of irregularities, I painted this piece [9] with gold dust.

U: That's why the gold is uneven. How about printed artwork? Do you still like uneven colors when it's a result of the printing process?

A: It depends on the artwork. Printing presses render details finer than our eyes can see. Sometimes that turns out to be a good thing, but sometimes the colors print unevenly even when you thought

(9)

you shaded everything perfectly. And sometimes when I'm told that it looks better that way, I'm like, "No, wait a minute. That part is supposed to be rich black." Or I tell them to make it even darker than the original illustration and ask for the black at 120% density or something.

U: Calling for a 120% color density is a bold move. I also give specific instructions for color in my work.

A: You specify color percentages too?

U: We live in a world of computers now. You can ask for a seemingly arbitrary number like 73% and that's considered normal. In the past, when you'd ask the printers to do something like a 3% halftone dot, they'd roll their eyes because you didn't have any professional training in printing. So you had to call for things in 10% increments. But it's anything goes now. As a matter of fact, I think you can convey your conceptualizations and intents better with the current system.

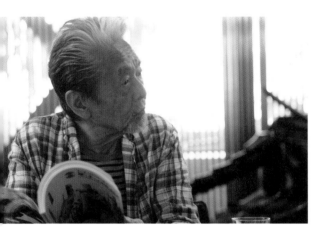

NOT BOUND TO REALISM

U: Amano-san, do you ever think about turning to realism in your art?

A: No, but I do admire that style. Which probably has something to do with the environment I came of age in professionally. As we were talking about before, I worked as a character designer for an animation production company. There was another department that handled all the background art, and those images were drawn in a realistic style. There were many people who specialized in that kind of art, and there was a point when I sort of made up my mind that I'd never be able to do it and gave up.

To be more specific, there was a man named Mitsuki Nakamura who did the art direction for *Gundam* and also worked on *Gatchaman* and *Honeybee Hutch*. He drew machines and robots too, of course, and I got to watch him do illustrations right in front of me many times. I'd draw the characters first to show him what they looked like, and then he'd redraw them. And when I saw the results, it was like, "Wow, I'll never be able

to be that good." Which is when I realized that I wasn't suited for that style of art.

U: I see. Films like Disney's *Snow White* have realistic backgrounds too. I always wondered why the backgrounds were done in a realistic style while the character designs are very simple and cartoonish.

A: While we're on the topic, you've never drawn backgrounds, have you?

U: Absolutely not [laughs].

A: But you've worked on animations too, right?

U: Sort of. The ones I did weren't in the usual style of moving images rendered from showing dozens of drawn illustrations per second. I would draw one illustration, but on something that moved, like a person's hand or whatnot.

A: That's interesting.

Editor: You were in charge of NHK TV's short animation segments, *Songs for Everyone*, right?

U: I used puppets in *Songs for Everyone*.

A: You make puppets too?

U: That's right. I like them, actually.

A: Huh.

U: How do you make the prototypes for things like this[10] [pointing at the large animal sculpture in Amano's office]?

A: For this, I created a small prototype out of clay first, and then I sculpted a statue at full size. I imported the finished statue's data into a computer, and once I did that, I could change the dimensions in any way I wanted and have the result manufactured. This version is about three meters long. But at four meters, it looks like an ox. Natural things all possess the right proportions that make them look beautiful.

U: I love the black material and texture. If you can create something like this, I'm sure you can design other three-dimensional works too.

A: I think so. Three-dimensional objects are interesting. And the images inside my head are sometimes three-dimensional to begin with.

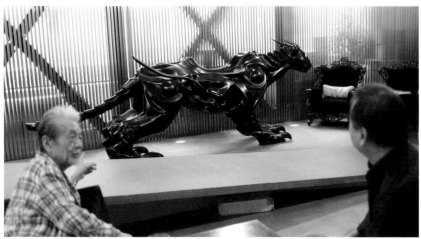

(10)

U: Like Taro Okamoto's *Suwarukoto o kyohi suru isu* (The Chair That Refuses to Be Sat On).

A: A chair for aestheticism's sake might be nice!

U: Exactly! Why don't you create a chair?

A: It's an interesting idea. But I'm no good with my hands.

U: But you created the prototype for this by yourself, didn't you?

A: I began working on it after I'd been messing around with clay together with a potter friend of mine.

U: Was it oil-based clay?

A: Yes.

U: Some parts of this statue are deformed. Oil-based clay is difficult to use, isn't it? And you didn't make the statue a shiny black.

A: I wanted it to have a matte finish.

U: There are circular hinges at the joints of its legs. Is that to give it a mechanical look?

A: Yes. The sculpture itself doesn't actually move but I have a long story inside my head about a warrior riding this beast to travel through time and various places to save the day.

U: I guess you're able to get the important aspects of the statue right because you've drawn so much in the past. But it wasn't like you did tons of plaster cast drawings to improve your technique, right?

A: No. It might be because of the influence from working on sci-fi animations when I was at the production company. Also, I really like robots.

U: When you say robots, you mean the kind of robots that are in animations, imaginary ones that can move around freely. Not the realistic ones whose moves are rather fixed.

A: That's right.

U: They're more interesting, aren't they? You know, things with dynamic, not fixed, movements. I think your sketches are like that.

(11)

A: On the other hand, there are things like this sketch[(11)] that I drew on a small sheet of paper.

U: Is this the original size?

A: The original's a bit larger than this.

U: It looks like *washi* paper. Has your taste in faces changed? You know, you've always drawn illustrations of girls, but they've changed over time.

A: I can't really tell, myself, but yes, I think there's been a gradual evolution.

U: When I see how my work has changed even though I didn't realize it at the time, it gives me joy.

A: I understand the feeling.

U: This might sound strange, but I don't want to create illustrations

where the character's face is so typical of my work that I could transpose it onto the body of a different character I've drawn and the illustration would still seem fine. The best thing would be for my artwork to gradually change even when I'm not really aware of it. On the other hand, I seem to keep drawing the same stuff.

A: Oh no, I think your style has been evolving over the years. That's why I was so happy to see the piece you made for *The Jaguar's Eye*.

U: Really?

A: Really. In your case, you can draw anything in a realistic style. But you still have your Akira Uno world, which is different. Your artwork is a distinct mixture of those two, so your recent works have brought me a lot of pleasure.

U: I'm very glad to hear you say that.

A: It's true. I've been reading the serialized novel in *Weekly Bunshun* that you do the illustrations for.

U: I come up with various plans when I'm working on a book illustration for a weekly magazine. In *Weekly Bunshun*'s case, I felt that they'd need one person who does illustrations in the realism style.

A: Ah, I see.

U: And if the magazine lacked humorous illustrations, I'd plan to do something like that [laughs].

INSPIRATION FROM ENVIRONMENT

U: In that respect, we're not the type of people who should be living deep in the mountains or locked up in some sterile room in Switzerland to create our work. We belong in the city.

A: Tokyo's the answer. For example, there was a time when I was in the Shinshu region and the illustrations I created out there were almost all of fairies and whatnot. Of course, there's nothing wrong with those types of things, but...

U: Right.

A: When I'm living in Tokyo, ideas like that don't come to my mind. The same with *N.Y. Salad*. I created that because I saw

the vegetables over there and thought they were cute. Our environment and work are deeply connected to one another. Your work changes depending on where you live. And although you can make a conscious choice of where to live, you continue to be influenced by many things around you whether you're conscious of it or not.

U: So even though we're not seeking out subjects to draw realistically, our surroundings are still important to our creativity.

A: You see all sorts of people when you walk around Tokyo or ride the train, and their hairstyles and clothing will change from season to season even if you're not concretely aware of the differences. We're probably influenced quite a bit by things like that.

U: But I don't want to look at the world around me with the eyes of a researcher. I don't want to dispassionately analyze them.

A: I agree. You shouldn't just study them.

U: And you shouldn't just reproduce what you study.

A: If you draw something exactly as it appears in reference material, you end up with a result that comes across as phony. Because that's not really you.

U: For example, a character description may say something like, "She was wearing red trousers and a blouse." And the illustrator assumes that because it said red trousers, the blouse must be a different color. But the blouse is just a blouse and could be any color.

A: That's a mistake, right?

U: Yes, it's a mistake. But as the book illustrator, I can't say that, so it's something the editor has to catch. And then you sound

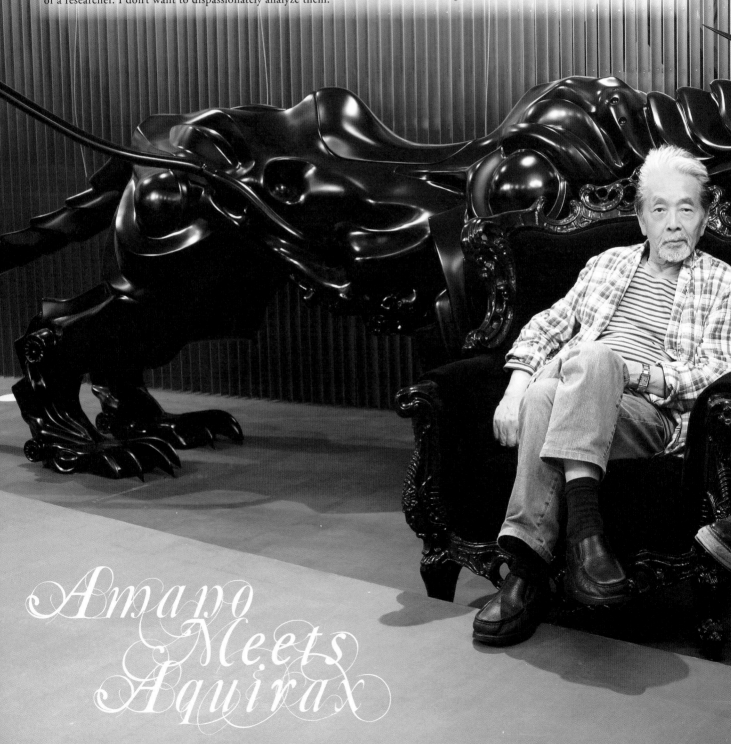

Amano Meets Aquirax

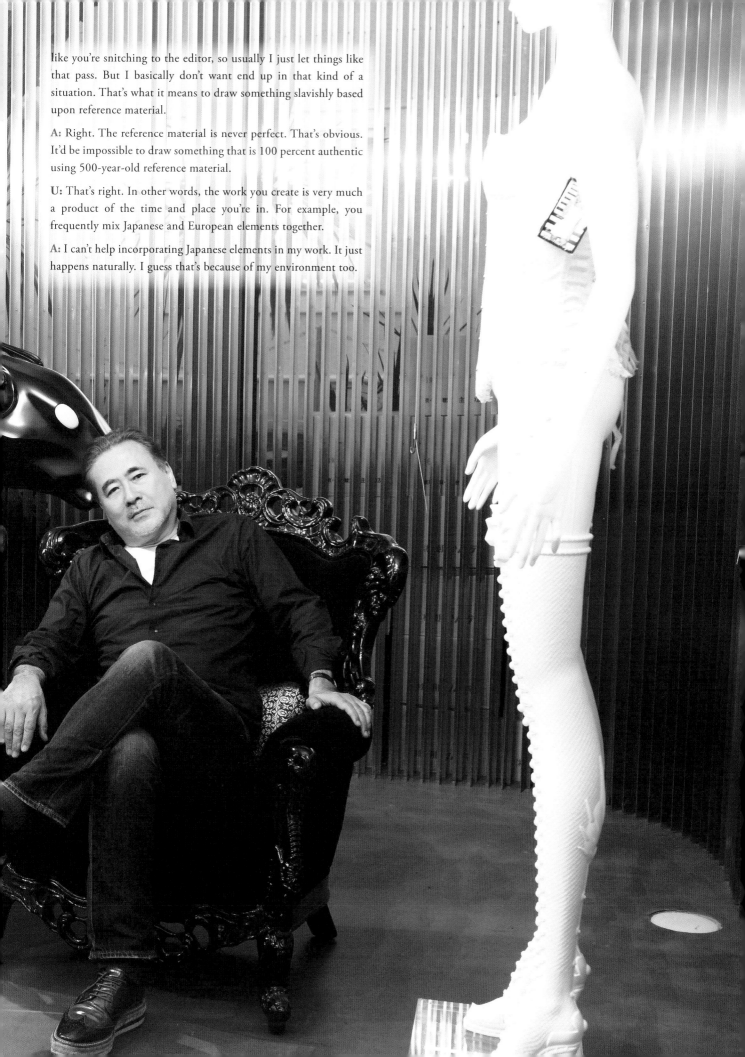

like you're snitching to the editor, so usually I just let things like that pass. But I basically don't want end up in that kind of a situation. That's what it means to draw something slavishly based upon reference material.

A: Right. The reference material is never perfect. That's obvious. It'd be impossible to draw something that is 100 percent authentic using 500-year-old reference material.

U: That's right. In other words, the work you create is very much a product of the time and place you're in. For example, you frequently mix Japanese and European elements together.

A: I can't help incorporating Japanese elements in my work. It just happens naturally. I guess that's because of my environment too.

WORKS THEY WERE INVOLVED WITH TOGETHER

Editor: I'd like to hear more about the time you two worked together at Shinshokan.

U: I don't really remember [laughs]. My job was something like Assistant Design Director.

A: He was in charge of the designs.

U: The Editorial Department had decided to hire Amano-san to create book cover art. And that's how we came to work together on the classical music and opera series we were talking about a moment ago.

A: That's right. Uno Sensei was in charge of the cover designs for Shinshokan's opera series, and I happened to be chosen as the illustrator to do the cover art for the books.

U: And later on, I also worked on the design of your art book, *Castle of Illusions*.

A: Right. The editor, Ando-san, suggested that I should have you design the book for me. And so introductions were made, and we met at your studio. You have no idea how nervous I was because I was standing in front of *the* Akira Uno. That was almost thirty years ago.

U: You were already famous back then. I remember that there were jigsaw puzzles of your work being sold.

A: Yes, there were.

U: Having your work used for jigsaw puzzles is an indicator that it's achieved a mass level of popularity. You created an illustration for a Kabuki magazine from Shinshokan too.

A: Yes. That was after the art book. I was given the opportunity to hold a conversation session with the famed actor Tamasaburo-san for my art book, and that led to my work with costume and stage design for Kabuki.

(12)

A: You designed these books[12] too [looking at Shinshokan's editions of *Tristan and Iseult* and *The Flying Dutchman*].

U: This was another opera series, featuring a lot of Wagner works. I think it turned out well.

A: I don't know why, but I was often given the Wagner assignments. The design of this series is very cool.

U: Shinshokan paid a lot of attention to the visual appeal of their books at the time.

A: I'd turn in an illustration for one of the volumes and then I'd let them design the book however they wanted.

U: Do you like Arthur Rackham and the illustrators from that period?

A: I'm a fan of Dulac and Kay Neilsen. I can say I've been heavily influenced by them.

U: Shinshokan has published monographs on all three of them. You had a very good relationship with Shinshokan, didn't you?

A: Yes. They expanded my horizons by having me work on things I had never encountered before. The opera series were works from the West, but I also created art for books by Kyoka Izumi, the novelist and Kabuki playwright.

U: Your encounter with Kyoka Izumi was a good one.

A: That was how I received the opportunity to work on the costumes and stage design of Tamasaburo-san's staging of Izumi's play *The Sea God's Villa*. So it all goes back to *Castle of Illusions*.

ON COLOR

U: You seem to be giving free rein to your colorful side these days.

A: Yes. When I began drawing illustrations I liked to use a more subdued palette, although every now and then I'd create something with bright colors. Nowadays, I'd say it's the reverse, that I create more colorful illustrations than subdued ones. And I don't draw the fine art pieces on paper—they're done on aluminum.

U: Oh, really? Ordinary painters will paint layer upon layer of oils, but according to what you said earlier, you use masking techniques to disassemble the colors to create your work.

A: Actually, you don't use regular types of painting techniques when you're drawing animation characters. The colors are all fixed and specified.

U: You use a color chart or something?

A: No, we have a special paint system that's used only for animation and that's fixed at a few hundred designated colors. And we specify which ones should be applied where by using numbers to designate them for the colorists. For example, if I wanted to use a certain yellow on a character's skin, I'd specify Y-20 or whatever, and the person who specializes in applying the colors will use that specific paint. So whenever I draw something, I already have in my head a good idea of what its colors should be.

U: That makes sense. It would look strange if a character's skin color differed from scene to scene, so for consistency's sake you ensure the same paint is used each time.

A: Sometimes, I'll draw a small illustration first and create the larger version afterwards, but that can be a pain because I basically end up having to draw the same thing twice.

CHANGING TITLES WITH THE TIMES

U: We've always been referred to as "illustrators," so it doesn't feel right when people call us "painters." Personally, I say I'm an illustrator, but what kind of title are you most comfortable with?

A: "Artist," I guess. "Illustrator" was a title created and used by people in your generation, Uno Sensei. Before that, there was no such term. I think that our titles change along with the trends of the time.

U: These days people like you are featured in *illustration* magazine, and those who did not formally study illustration are actually starting to do a lot of work in that world. For example, you see manga and comics artists doing book illustrations now.

A: Yes, there's a lot more of that now.

U: So if I were a graphic designer or art director on the hunt for a cover image, I'd look for something that best suited my needs. Maybe something with more *oomph* that would stand out at the bookstore, or maybe something that happened to suit the contents of the story perfectly. And in that case, I feel that I wouldn't necessarily have to look for someone who was trained in illustration. Whether that person is a painter or a photographer, their work turns into a cover illustration the moment we use it as such, since the most important criteria is that the piece be effective. So in some ways, this might be a tough time for people who grew up and studied in an illustration environment.

A: You may be right. For me, *illustration* magazine was an exciting source of inspiration. From there I discovered the work of people like Pater Sato, Antonio López, and you too, Uno Sensei. I was exposed to a lot of new things through that magazine, and now that I look back on it, I was also influenced by them. I don't know if that was good or bad in the end, but regardless I was very excited to read the magazine because it felt like I was being given a glimpse into future trends.

U: These days you don't see illustrators who can exemplify and dominate the visual landscape like Tadanori Yoko did in the '60s and '70s.

A: That's probably the case all over, not just in Japan.

U: Really?

A: I went to New York in '97, and although I didn't live there full time I often visited the city and had my own studio there too. And there weren't any figures like Warhol or Antonio López on the scene. As a matter of fact, there weren't many artists around at all. That came as quite a surprise to me.

ON STAGE DESIGN

U: I wanted to ask you about what it was like working with Tamasaburo Bando and what he wanted from you.

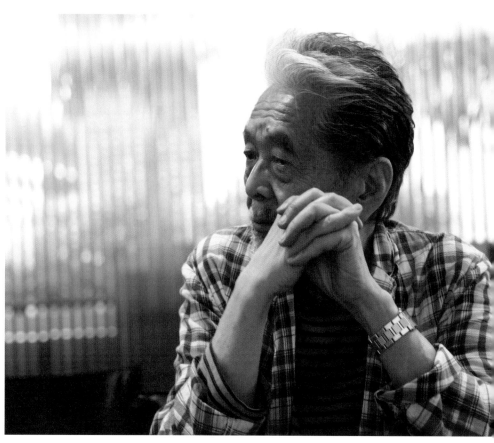

A: He already had a perfect image in his head of what he wanted to see.

U: I can imagine.

A: My job was simply to reproduce that as an illustration.

U: There's a scene set on the seashore in *The Sea God's Villa* where people—maybe the actors themselves—tried to represent the flowing waves with the movements of their bodies.

A: There were cast members who specialized in things like that. I think you wrote about this at some point too, but after I worked as a stage designer, I realized that the stage belongs to the actors.

The reason I became interested in the theater in the first place is because I thought it might help me develop my artwork. Plays aren't flat works of art, they're three-dimensional. Of course it's the stage carpenters and managers who do the actual building, but I wanted be the one to come up with the ideas.

I wanted to learn and draw inspiration from my experiences with the theater. The reason behind that was because I wanted to work in opera. I had a very strong interest in opera, I think stemming from the fact that the music and lyrics are always the same no matter who performs them. So what creates the difference in performances? The stage direction, of course. Operas can differ greatly through the visual interpretations of the stage directors, which can be very daring at times. I thought I couldn't be as daring as that with my own illustrations, so I wanted to learn about that approach and mind-set from theater.

U: Budgets are a constant problem in theater. How a production goes depends on whether the stage director makes full use of the budget and tightly controls it, or if he allows the artists to do what

they want. In Europe production budgets for operas like *Carmen* can be unbelievably large. For example, in a production of *La Bohème* they even used real snow so it would look more realistic when it was melting around the fireplace.

There's a Fellini film called *And the Ship Sails On*. It's the story of a funeral voyage for a great singer's death. There's a scene set on what seems to be a balcony, and the set is like seven meters tall, so the camera angle has to travel up and down. The movie takes place mainly inside the ship, but the fact that Fellini went to the effort to make this scene with this unusually high shot must be because he had a vision in his mind that he wanted to create.

Even if a director didn't have brilliant visual ideas like Fellini, he could still create something relatively interesting if he let the artists do what they want to. But you can't expect anything interesting from a stage director who has a totally ordinary visual inside his head and just wants to duplicate that on the stage. It's a lot more fun to work with a stage director who's willing to do something unusual or over the top.

But despite all that, one still has to think about the budget. The play you worked on at the Kabuki Theater had its own stage set department, and they'd create what you'd drawn as an illustration, right? But in the theaters I worked with, if they needed an illustration that was two meters high, I had to make one two meters high by myself. I ended up hurting my back doing that work. But I still kind of enjoy doing pieces like that on deadline because it shows me that I have enough stamina to pull it off.

A: I'd love to see those stage settings you worked on.

U: You can see samples of them in the book *Aquirax Works*[13] that was recently published.

A: I can't wait to see it.

U: Things are a lot easier now because you can draw something at a normal size and then just digitally enlarge it.

A: Yes, that seems to be common.

U: But the not-so-rich theater troupes I'm involved with actually make those large sets by themselves. And you need a lot of stamina to do it. But that part can be fun too. You just have to enjoy the labor process.

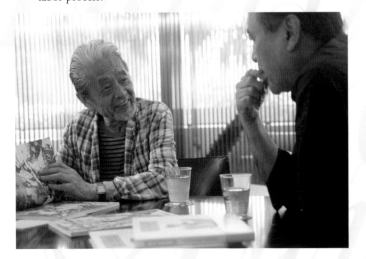

A: It must be very hard to make money with theatrical plays. It's probably difficult for anyone who doesn't have a grand vision.

U: People who make plays and movies are bound together by vision and determination. They don't worry that much about the money side of things.

A: In addition to interesting and daring stage direction in theater, I'm also impressed with the lighting. It looks like they're painting with light. The stage is the canvas and the lighting is the paint.

U: And the actors on the stage are like the brushstrokes.

A: Yes, exactly. There was one time when I had the chance to experience it firsthand. It was in one of the plays Tamasaburo-san was directing, and he was giving a lot of instructions to the lighting people. I thought the lighting was already very beautiful, so I said, "It looks fine," but he answered, "No, this isn't right." He said it wasn't natural enough.

There were probably specific colors he was trying to avoid, and I'm sure everyone has their own methods of doing it, but when they finally lit up the stage in the way he wanted, it really did look like natural lighting. It was very impressive. The lighting staff were veterans of course, but their work changed when they followed Tamasaburo-san's advice.

U: Stage development is a very interesting process to observe.

A: It was like they were drawing. When you use paint, you've got solid colors, mixed colors, and ways to make every color in between. They were doing the same thing with the lights.

THEATRICAL STAGES ARE MEANT TO BE SEEN LIVE

U: Do you ever watch Takarazuka productions?

A: I had the opportunity to work on their stage design once.

U: Oh, really? They spend a lot of money on their sets. They sometimes use horses and the horses look like they're flying through the air, but they're actually being hoisted up by huge machines. That's a fun way to use a production budget.

A: You should do some work for them too, Uno Sensei. You could create a very mystical-looking stage. I'd love to see it.

U: How about its reproducibility? Did you get exactly what you created in your illustration?

A: I wasn't able to be too involved. I just drew the illustrations and I had to go straight to New York after that, so I had someone else take care of it.

(13)

U: I see. How was it working with the Kabuki Theater?

A: That was great.

U: The stage set department of the Kabuki Theater is famous for the quality of their work. They even get job requests from the outside.

A: Right. They did the same play at a hall in Osaka and at the Nissay Theatre too.

U: But you know, you can experience the true essence of a theatrical stage only during a performance. It's not the same in a photograph.

A: It's not even the same in a video recording.

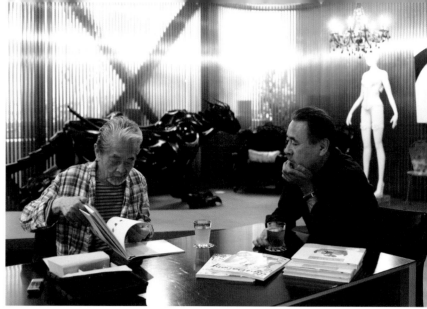

U: Or a televised broadcast of the performance. A play encompasses everything that's on and around the stage, including the corners that the TV cameras can't catch or the areas that are missed when the camera moves around. Or in situations like when, for example, yellow lighting is used make the things onstage seem yellow, but the people who are watching at the theater know that the performer is actually wearing white.

A: You're exactly right.

U: You have to watch the live performance to see all of that.

A: That's because otherwise you aren't sharing the same space, which is an integral part of the performance. To have the full experience, you have to watch it live. Even the smell of the theater is important, I think.

U: I agree.

A: For example, if they use a smoke machine, you can smell the smoke.

U: Right.

A: The smell is important. That's definitely the case with the Kabuki Theater. That smell has a distinct allure to it.

U: It does. I'm jealous that you got to work together with Tamasaburo-san.

A: That was a very enlightening experience. And it was was brought about by *Castle of Illusions*, which you did the art direction for, Uno Sensei.

A WIDE RANGE OF WORK

Editor: Your conversation so far has made it clear that you've both worked extensively on a wide range of different things. Has that been deliberate?

U: What about you, Amano-san?

A: I think the job of creating illustrations is like working at a restaurant. Someone who wants a variety of dishes can go to a Chinese restaurant, and if they want sushi, they'll go to a sushi restaurant. But if you say you're a sushi chef and therefore will only ever make sushi, then people who want to eat other things won't come to your restaurant. You limit the dishes you cook and that limits the range of jobs you can take on. But I think the world of illustrations should be a lot larger than that. Just because you trained in a sushi restaurant, that doesn't mean you have to be limited to that for the rest of your life: you can learn to make all kinds of dishes. Of course, no matter what you make, the important thing is that it tastes good.

In the modern world jobs come and go based on trends and technology, so there is always a possibility that one job will become obsolete and a new job will appear. The best thing to do is to keep drawing illustrations that you love and figure out how to make your living through them. Of course, you have to keep taking different jobs to make ends meet. But you also need to keep drawing diligently outside of that work for hire or else you'll never be able to do something new. So you shouldn't limit your range of work and should always be thinking about ways you can create happily and freely.

U: That's right. You have to enjoy what you're doing and you need to keep at it until you're happy with what you create. And if you enjoy your work, it can lead you to new things, like how your book *Castle of Illusions* opened a path for you to work in Kabuki.

Even if you want to work as a stage director for Kabuki, it's not easy to create new ideas to use for Kabuki and to market yourself only to the Kabuki world. So the best thing would be to build a situation for yourself that will open you up to attracting clients. To put it simply, you have to create your own luck. It was luck that brought you and Tamasaburo-san together.

We've been able to work on such a wide range of things not because we had experience in all of them but because people thought we had the potential to do them. For example, we know the kind of work you can produce based on European folklore, so what would happen if we asked you to do something based on Japanese or Chinese folklore? We create things on a constant basis that trigger new ideas in our clients' minds. It's not like we prepared samples of what we wanted to do and placed them out on display. Our daily work is the display itself.

A: I think that's right.

(END)

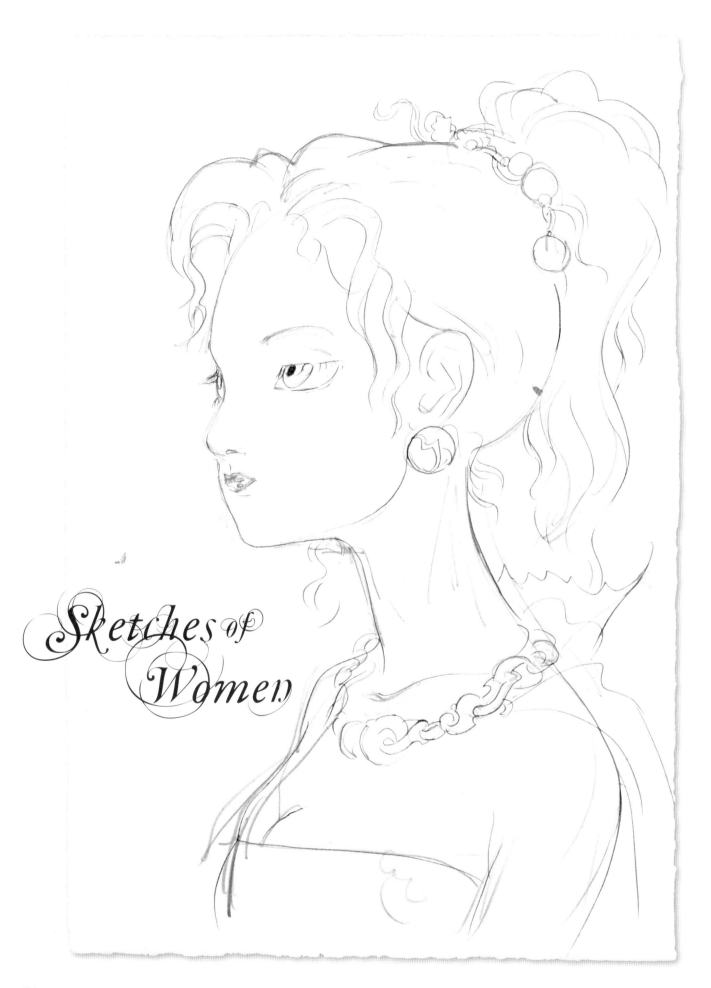

Sketches of
Women

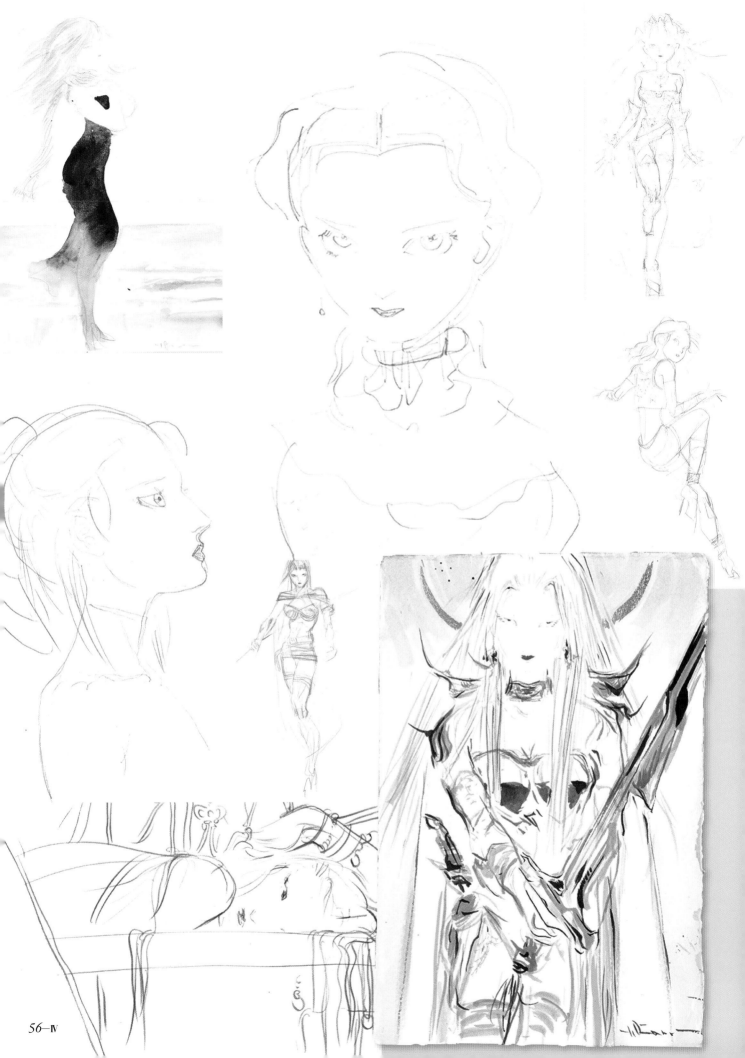

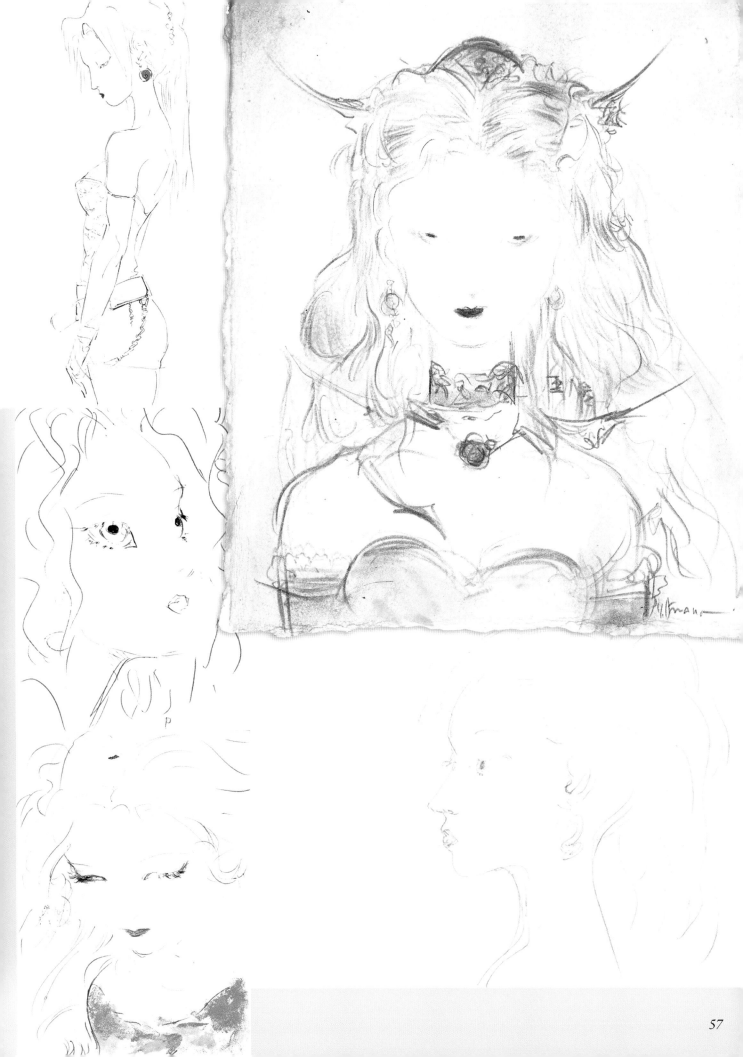

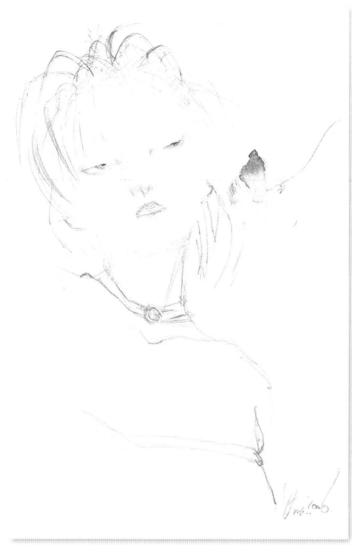
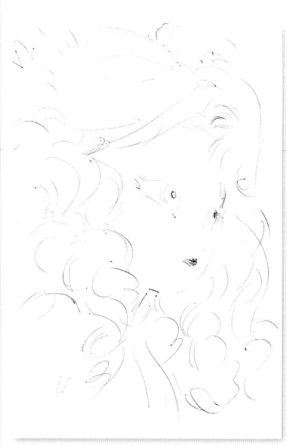
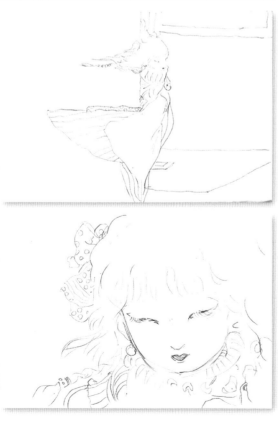
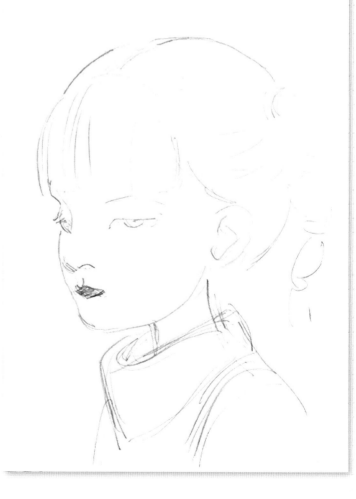

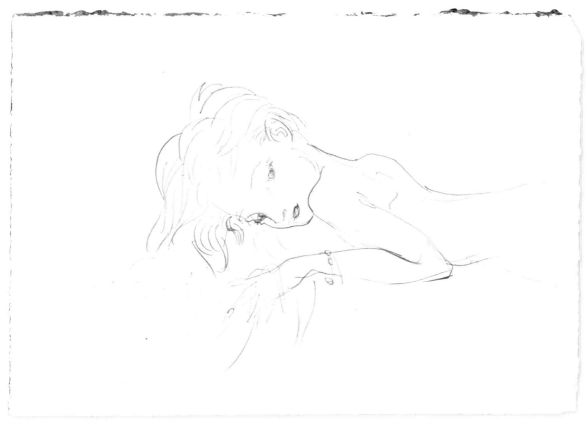

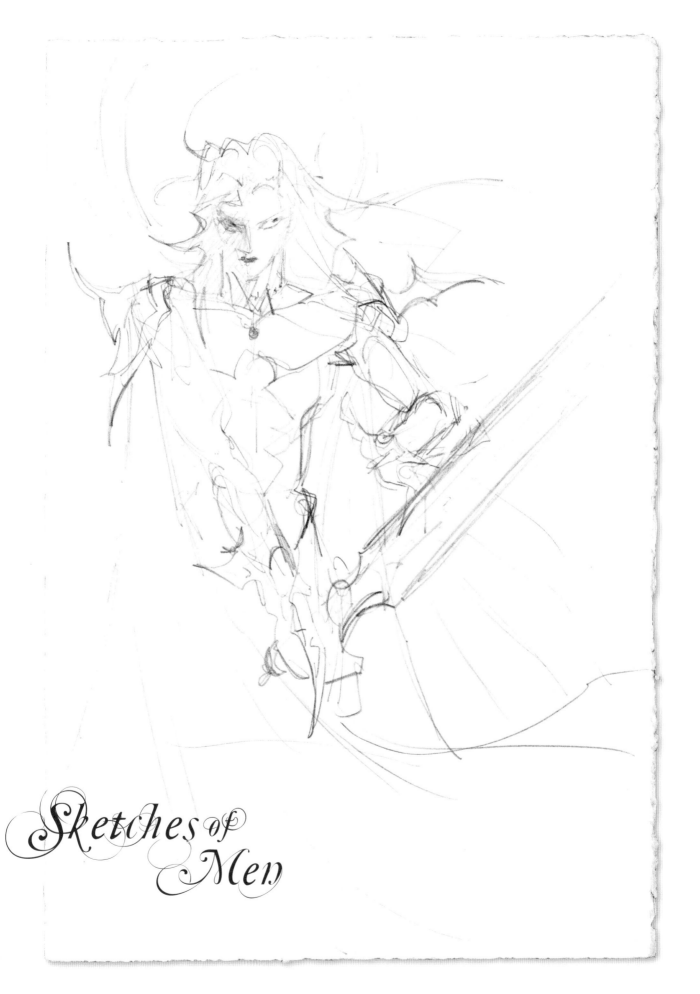

Sketches of
Men

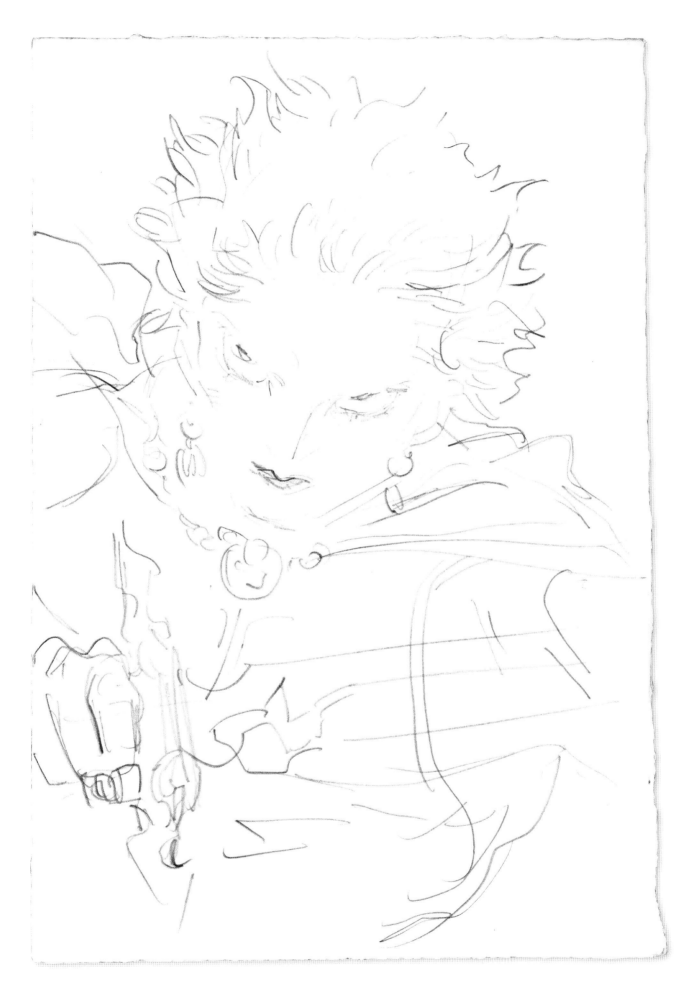

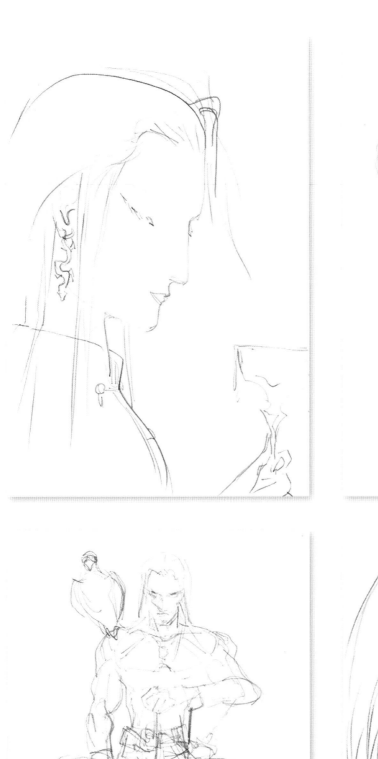
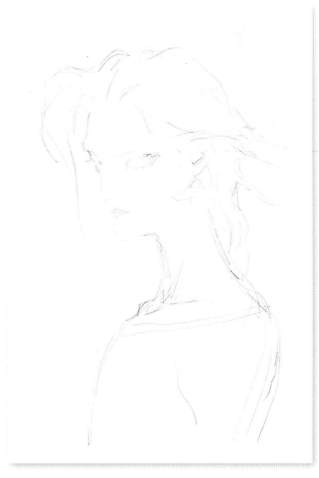
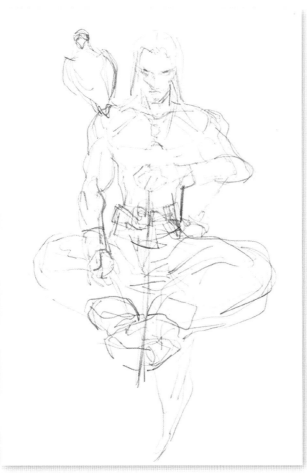
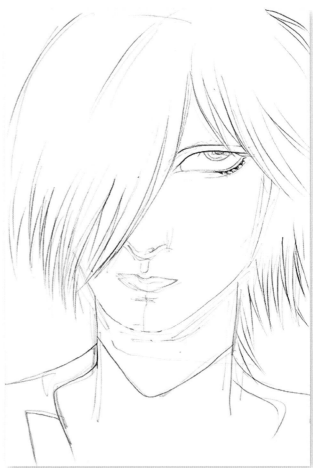

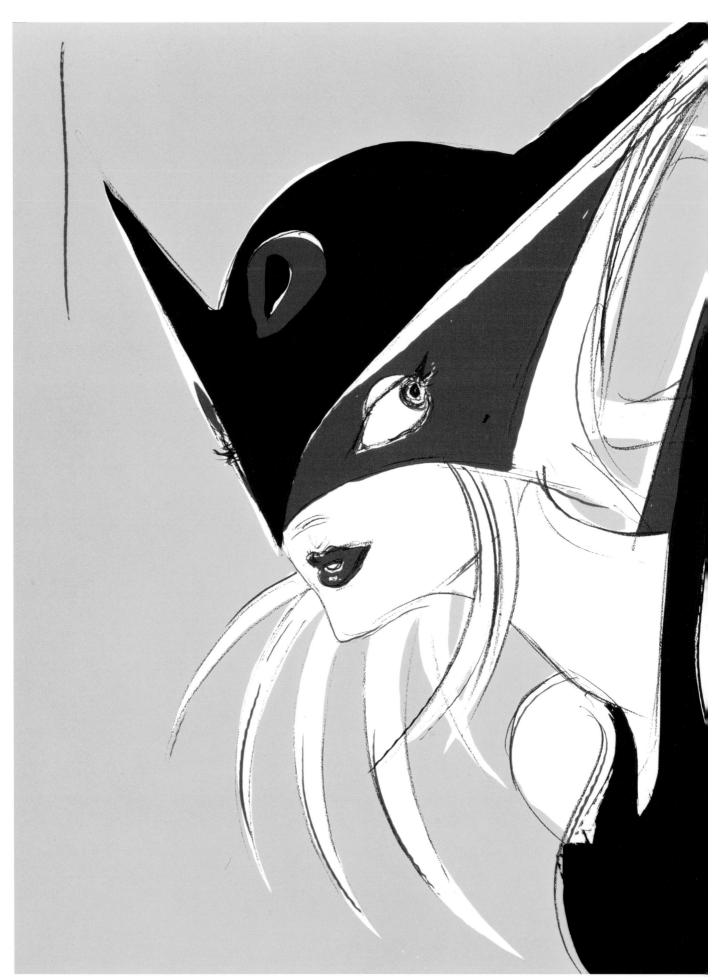

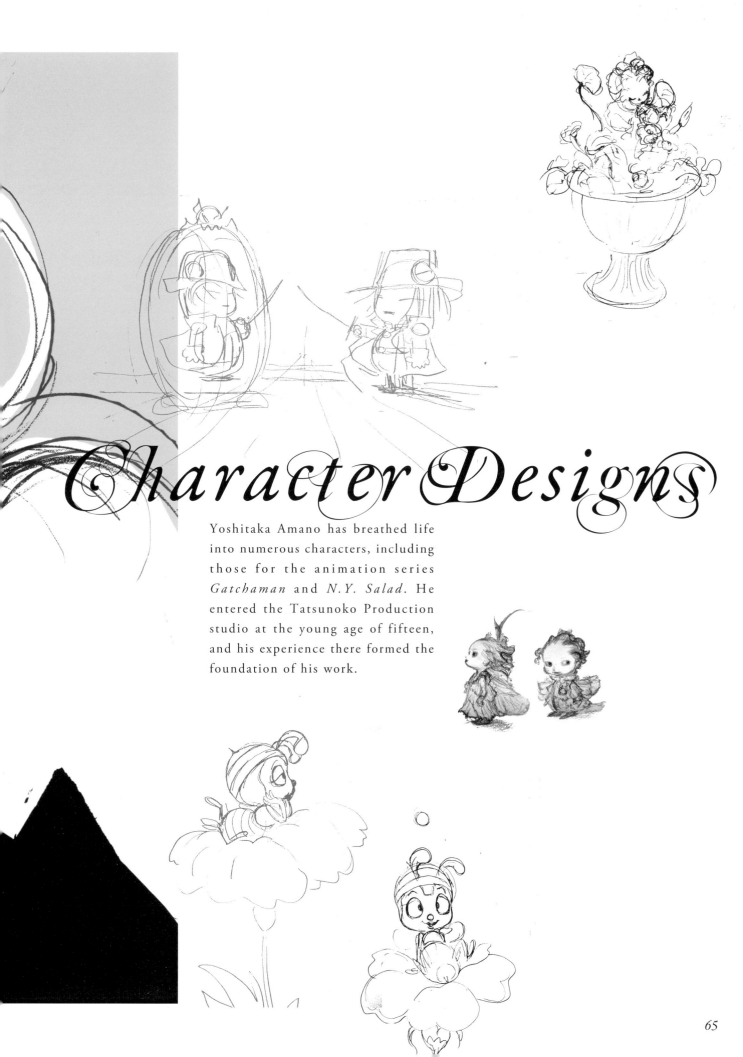

Character Designs

Yoshitaka Amano has breathed life into numerous characters, including those for the animation series *Gatchaman* and *N.Y. Salad*. He entered the Tatsunoko Production studio at the young age of fifteen, and his experience there formed the foundation of his work.

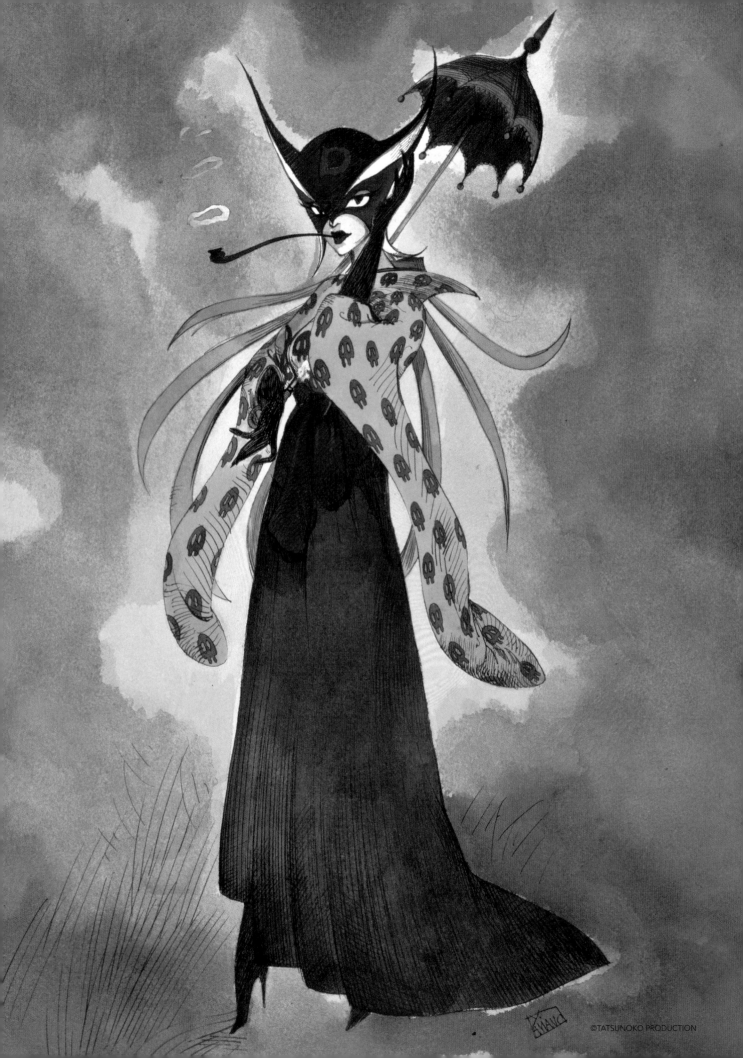

©TATSUNOKO PRODUCTION

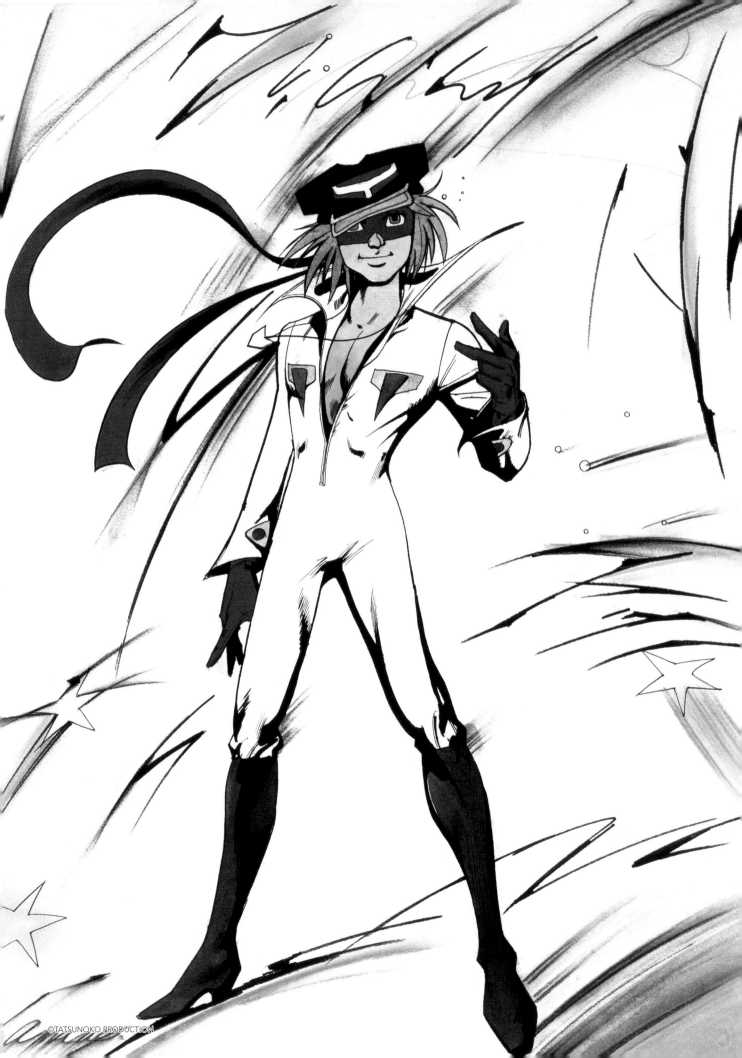

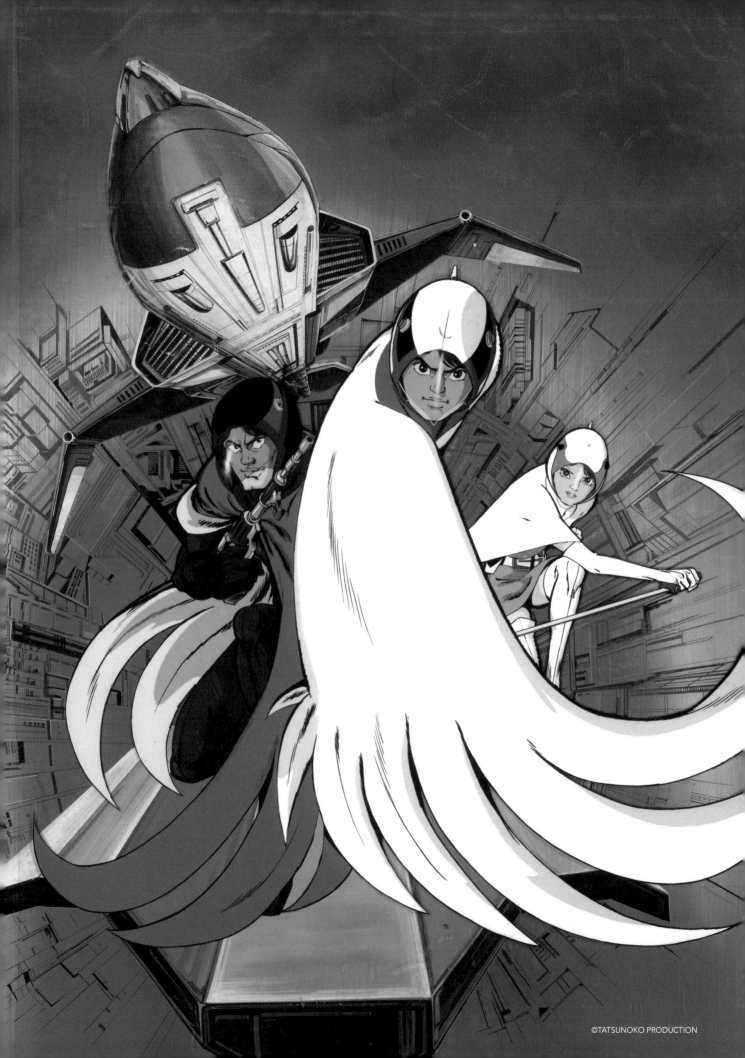

©TATSUNOKO PRODUCTION

©TATSUNOKO PRODUCTION

AMANO ON TATSUNOKO PRODUCTION

My roots lie in the works I created for Tatsunoko Production. I made them as part of my job, so I'm not sure if I can call them my own, but I believe that my experience from back then is reflected in my current art style. My work at Tatsunoko paved the way for me to enter the world I live in now. It all started there.

©TATSUNOKO PRODUCTION

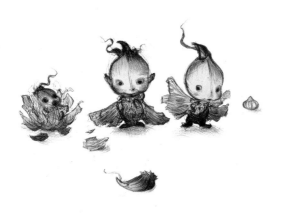

 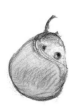 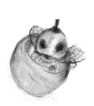 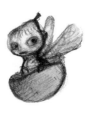 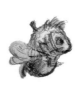 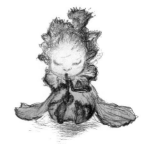

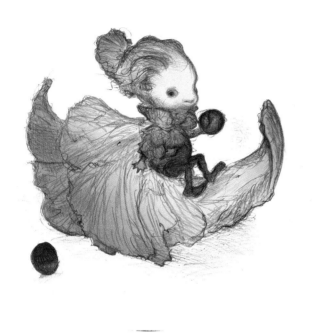

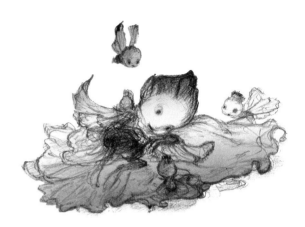

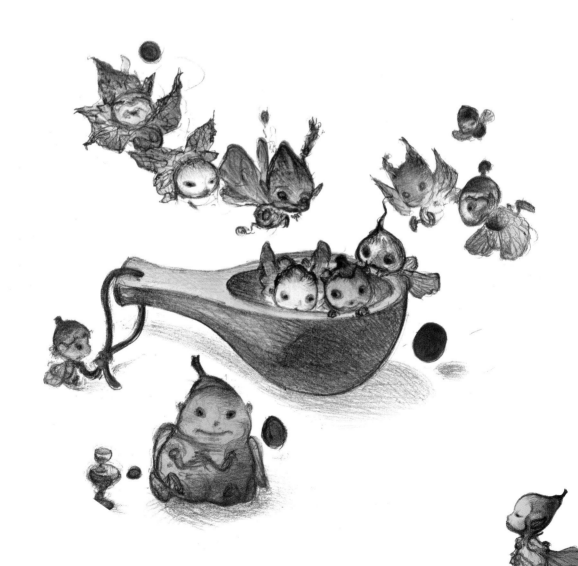

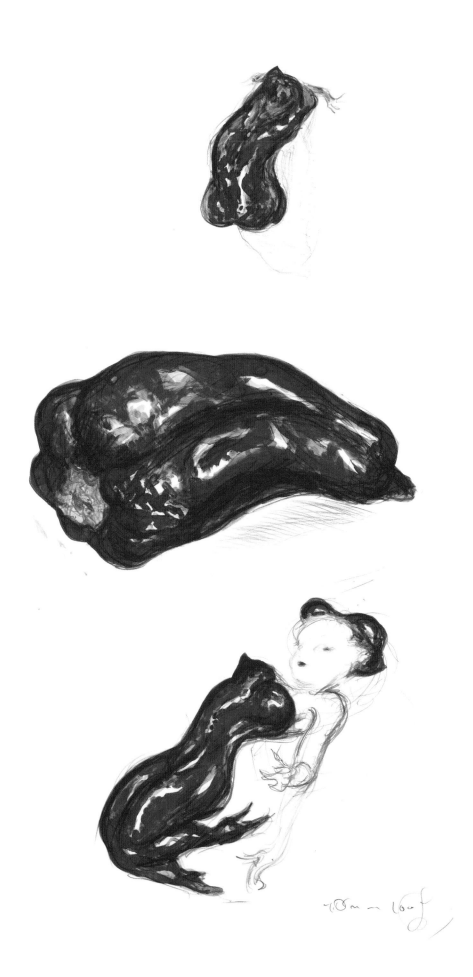

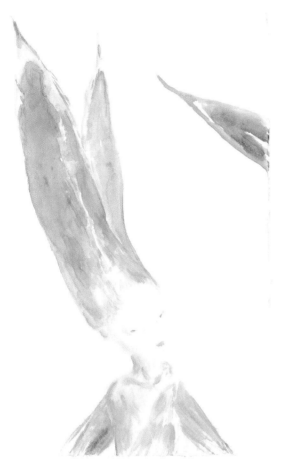
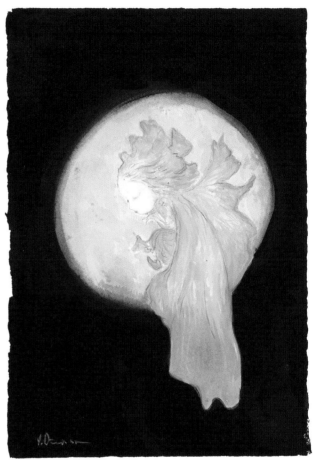

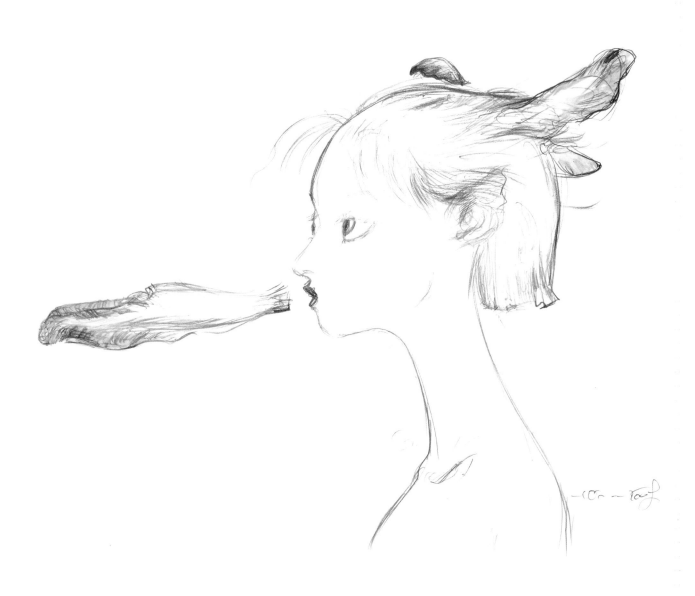

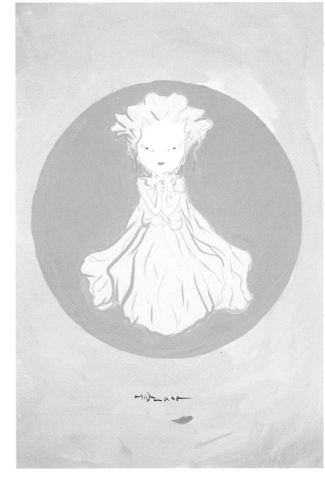

AMANO ON N.Y. SALAD

These fairies are characters created from the sketches I drew during my free time when I was cooking the vegetables they're based on. I never meant to show them to anyone, but since I had drawn over a hundred sketches, I agreed to publish them in a book, and then an animation was adapted from them. The pieces included here are my sketches before the designs were finalized, along with a few that have not been published until now.

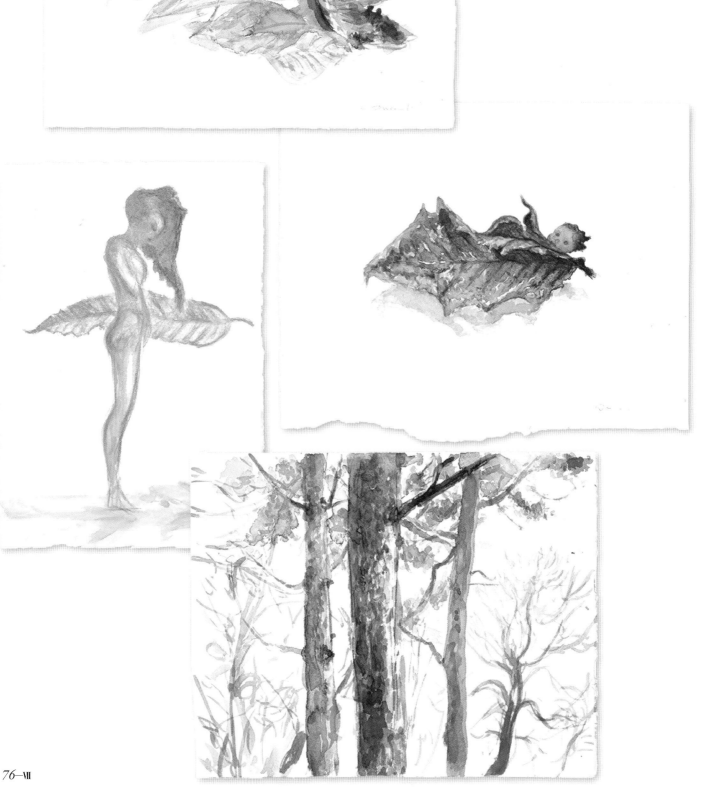

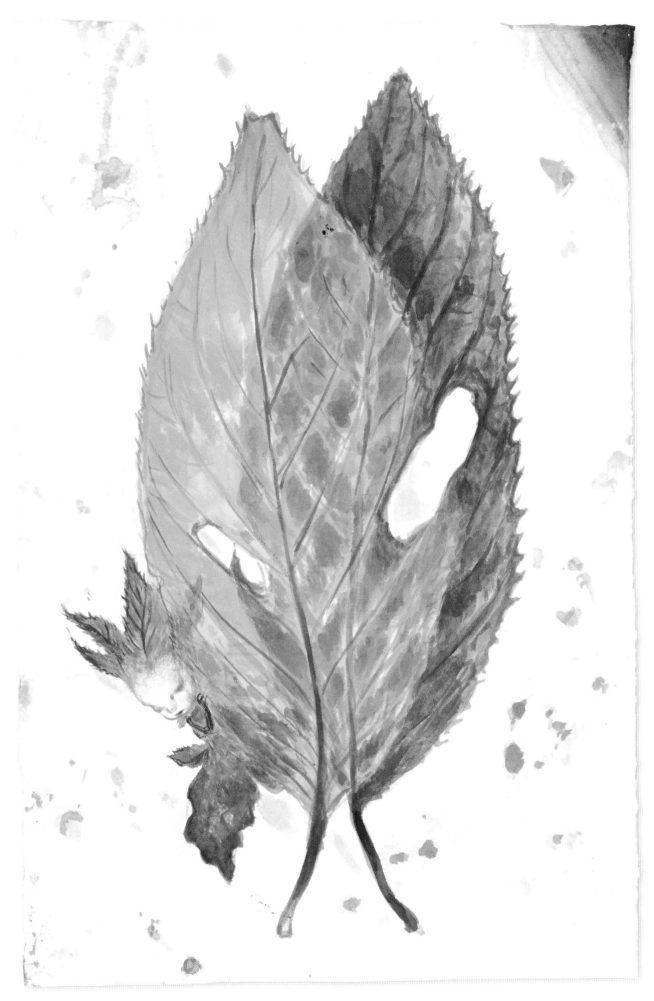

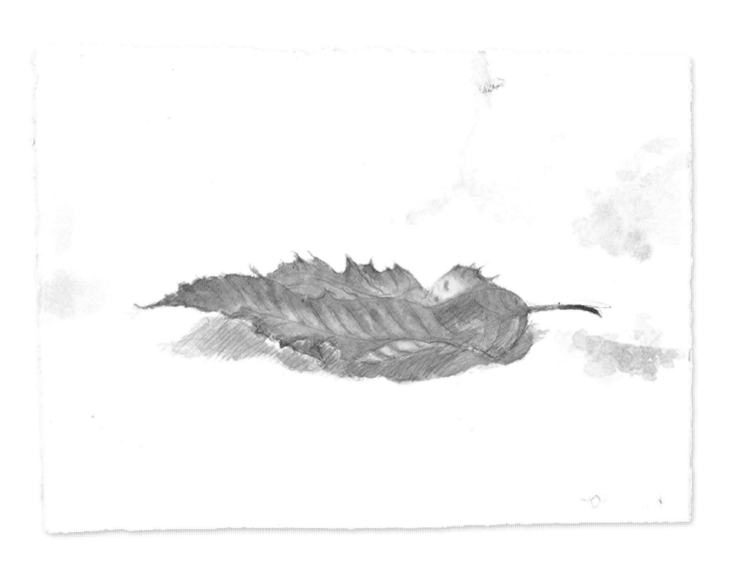

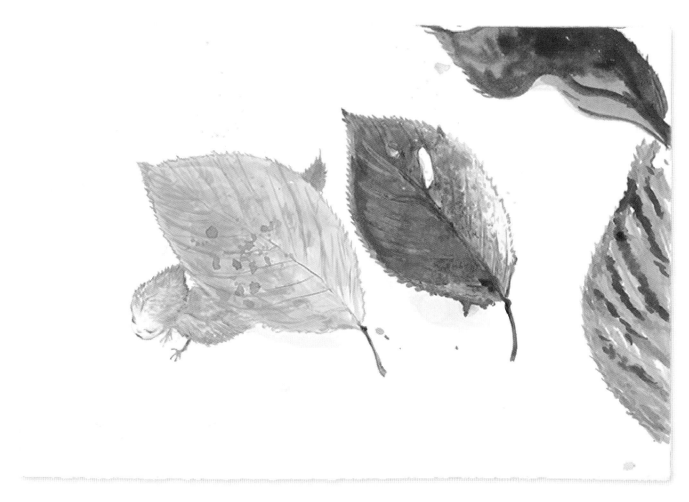

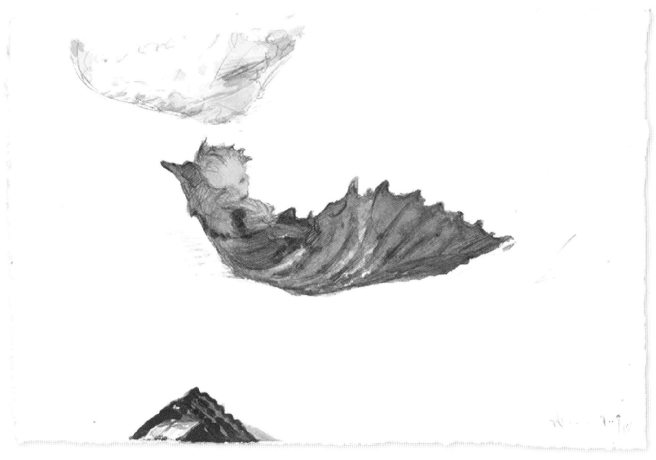

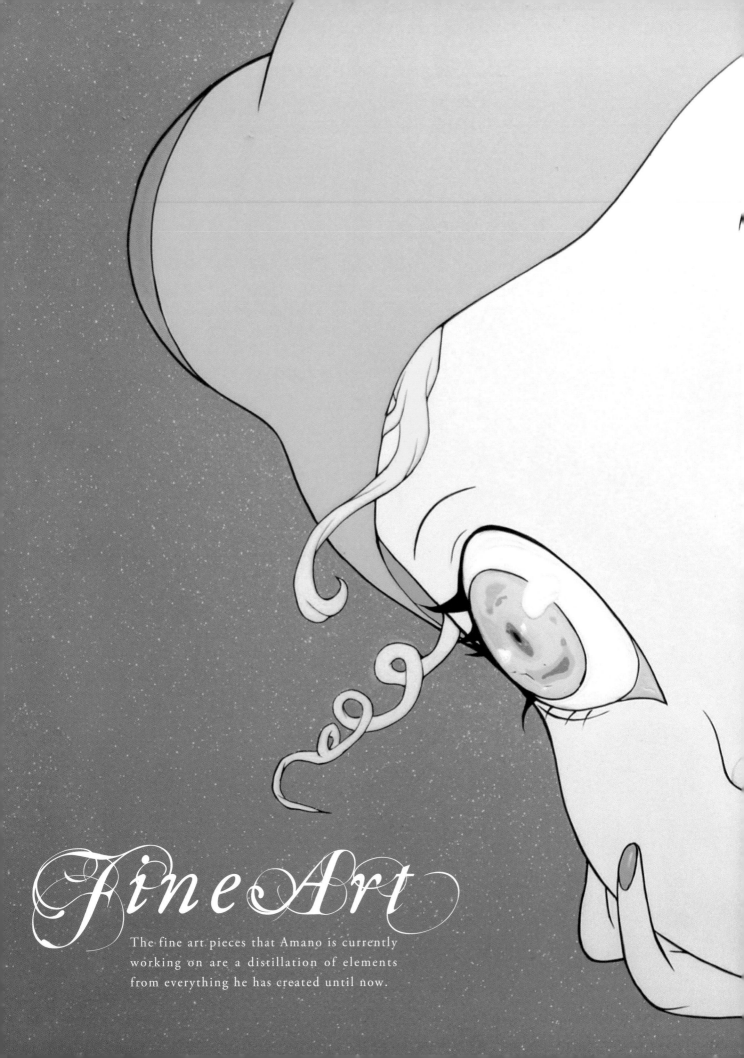

Fine Art

The fine art pieces that Amano is currently
working on are a distillation of elements
from everything he has created until now.

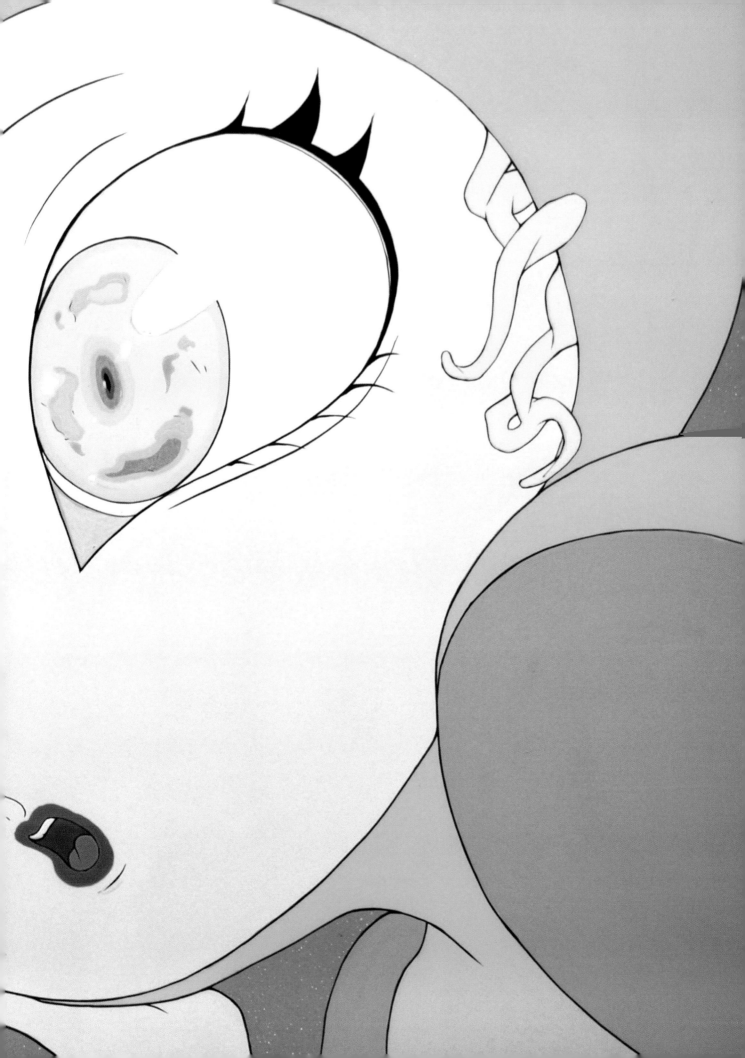

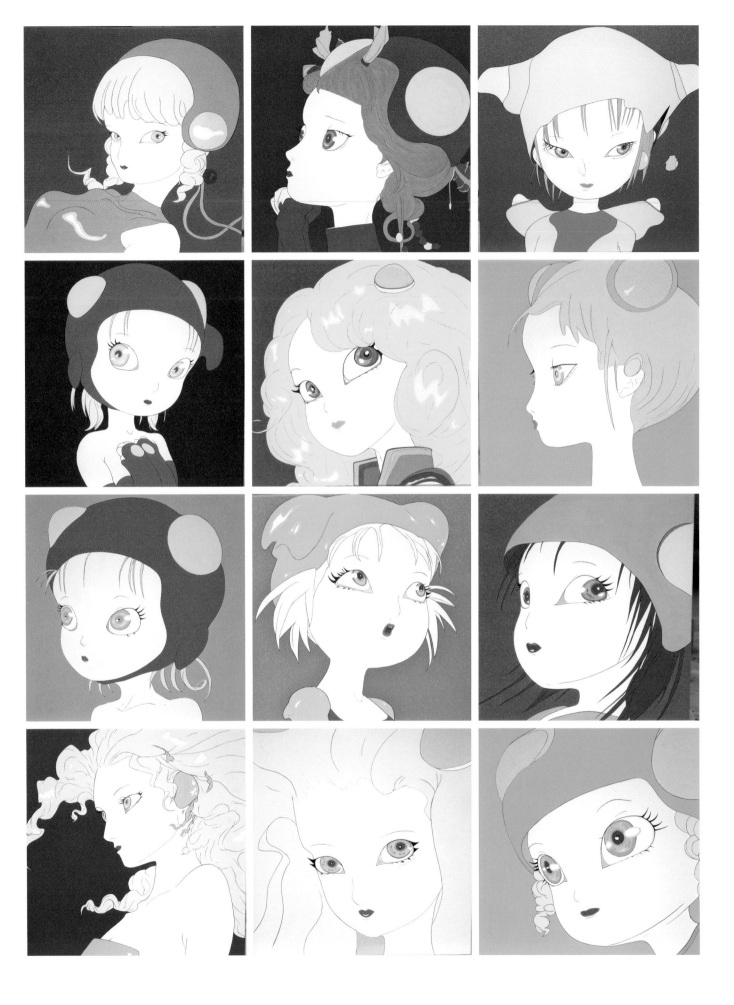

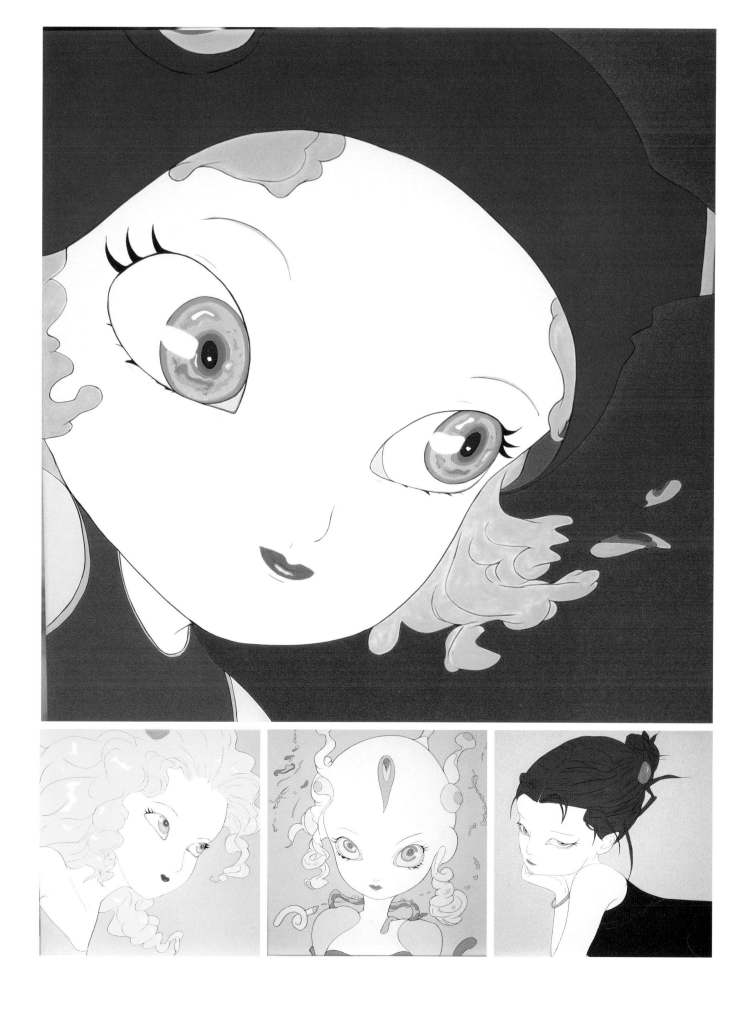

AMANO ON FINE ART

The reason why I don't use much color in some of my pieces is because I feel that the world of fantasy doesn't have a lot of vivid color. It's more sepia-toned. Personally, I like to use color, but I won't do so if it doesn't fit the world of the novel. I didn't create the world inside that novel: the writer did. It's my job to depict that world with my illustrations.

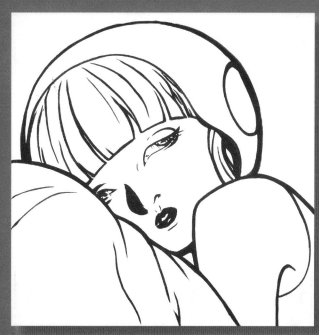

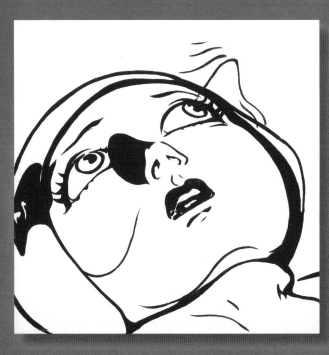

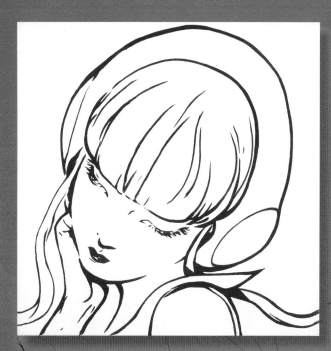

My fine art pieces, however, are not bound by those kinds of considerations. I'm free to do whatever I want, I can use any colors I want. I'm liberated, in other words. So when I work on my fine art, it's not that I always actively want to use color, but rather that I'm free to do so.

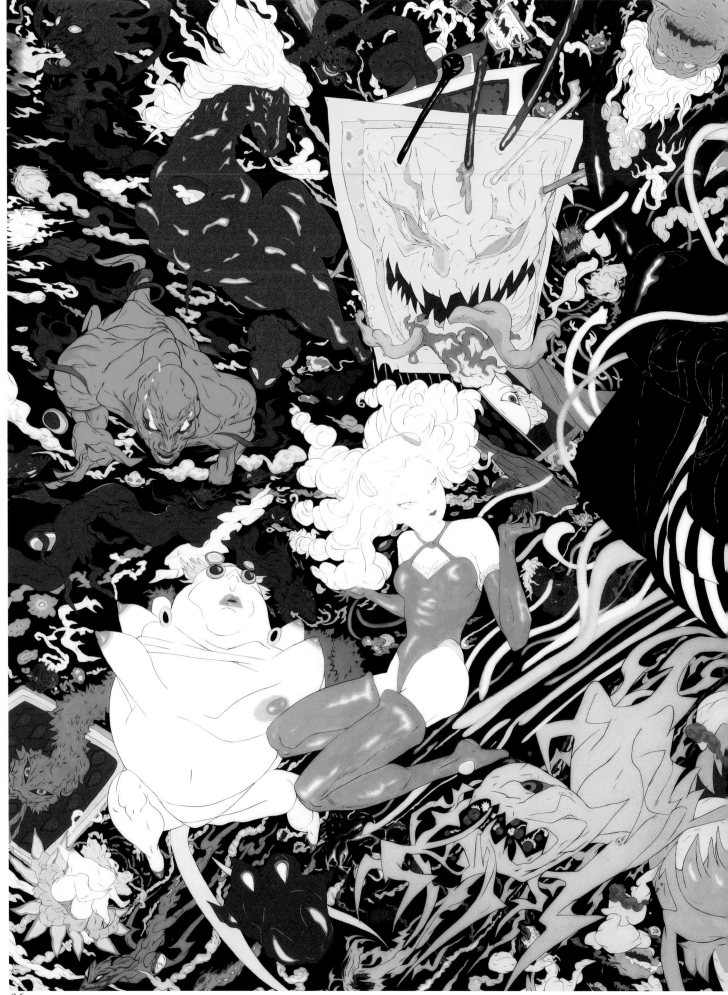

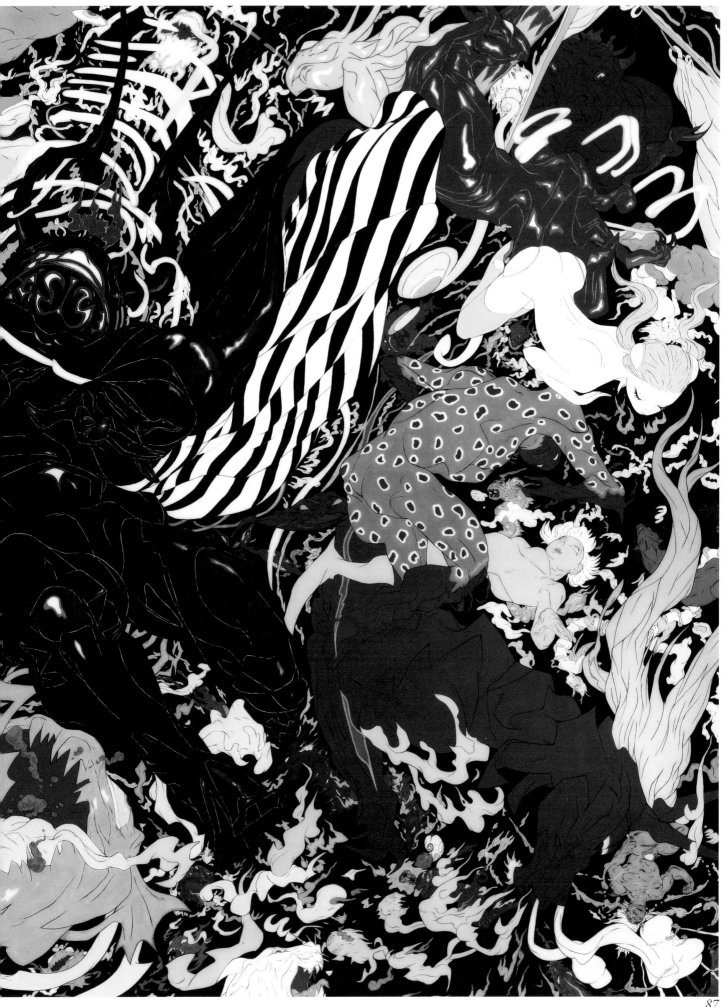

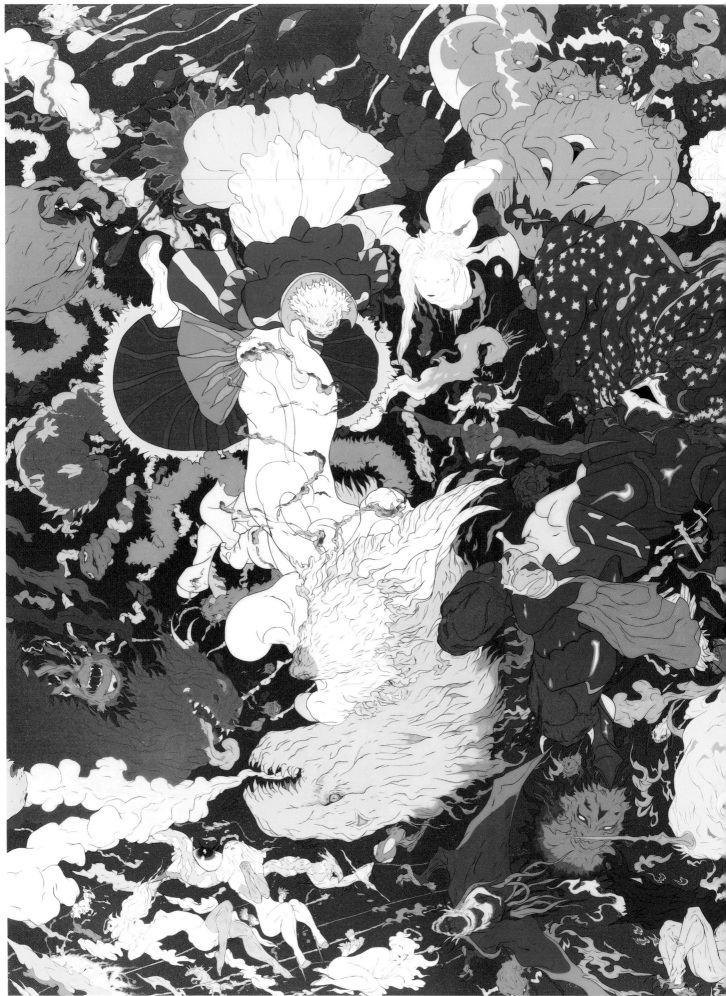

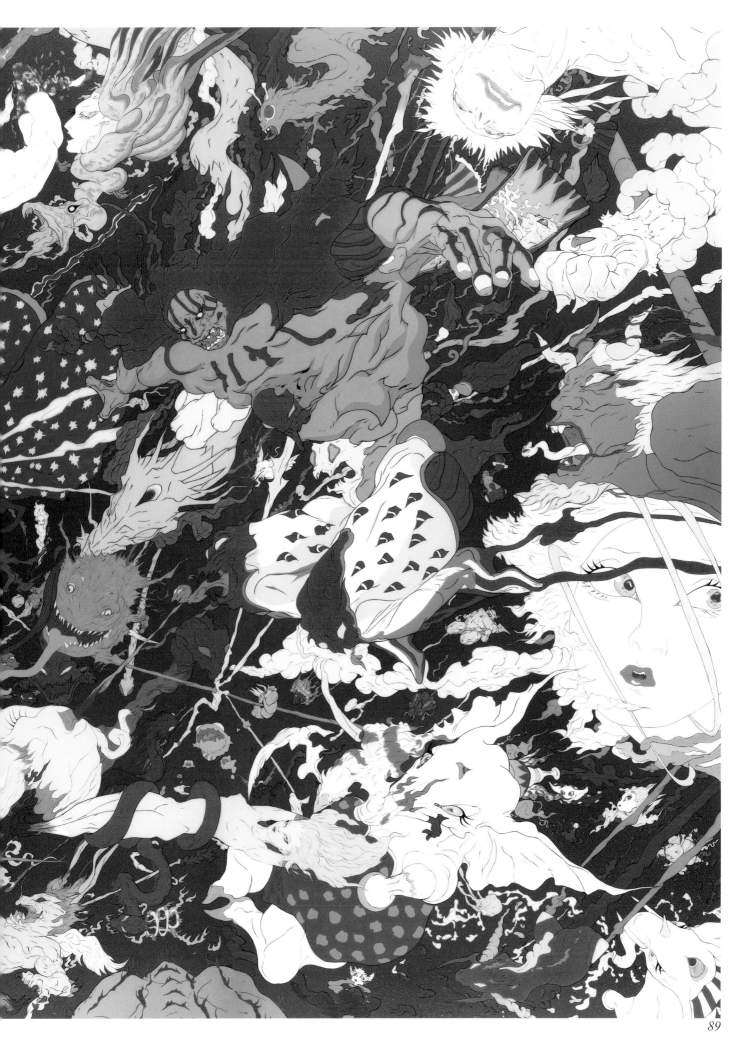

Hero

Hero is an original property that Yoshitaka Amano has been creating thematic works for on an ongoing basis. He has portrayed this unique world using various methods, including paintings, lithographs, and three-dimensional artworks. Free from any outside restrictions, this series provides space for Amano to showcase his artistic powers.

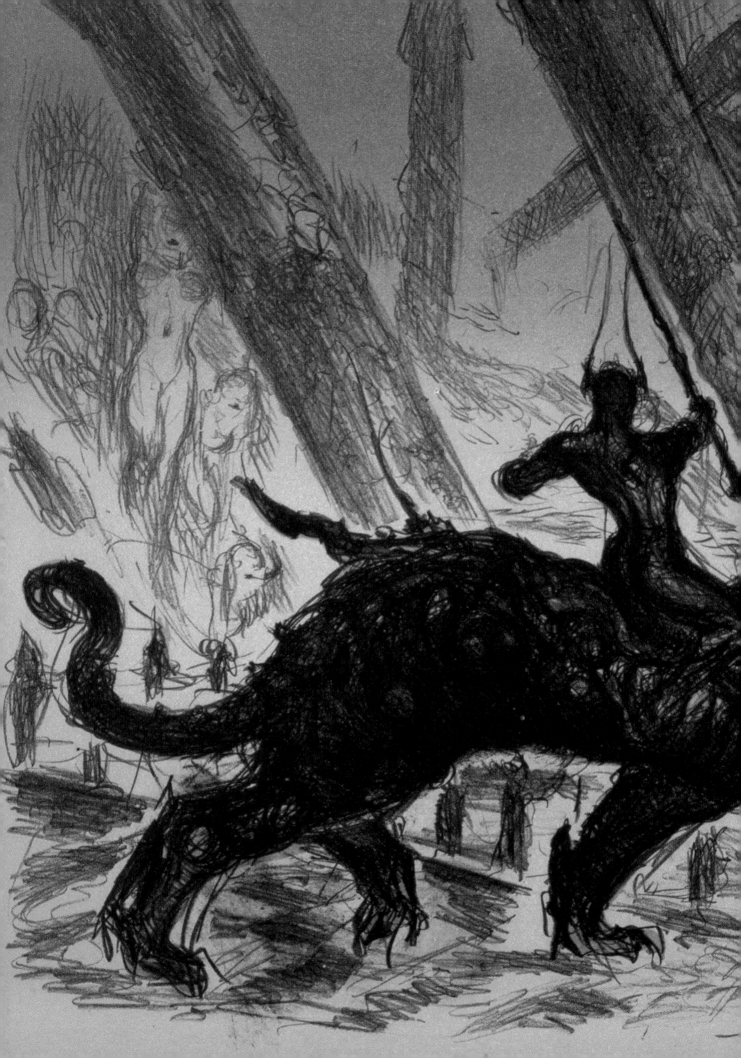

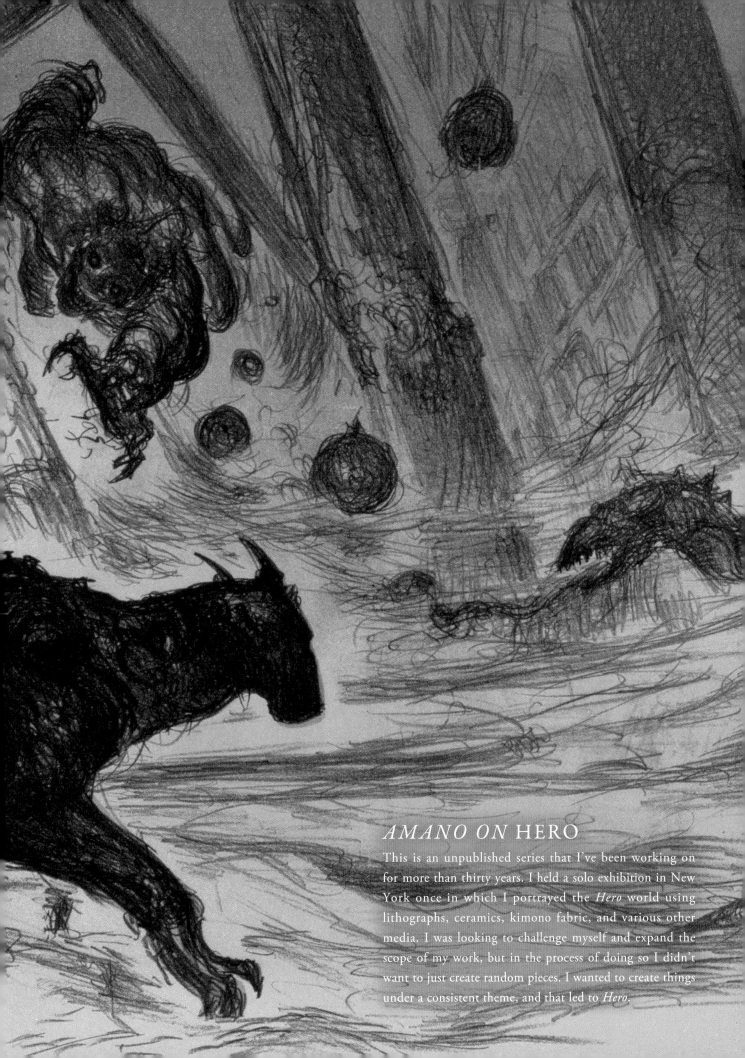

AMANO ON HERO

This is an unpublished series that I've been working on for more than thirty years. I held a solo exhibition in New York once in which I portrayed the *Hero* world using lithographs, ceramics, kimono fabric, and various other media. I was looking to challenge myself and expand the scope of my work, but in the process of doing so I didn't want to just create random pieces. I wanted to create things under a consistent theme, and that led to *Hero*.

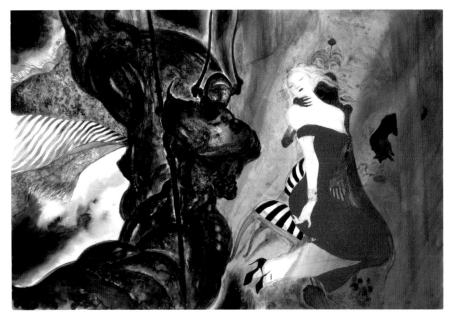

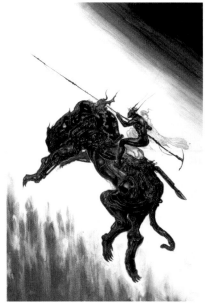

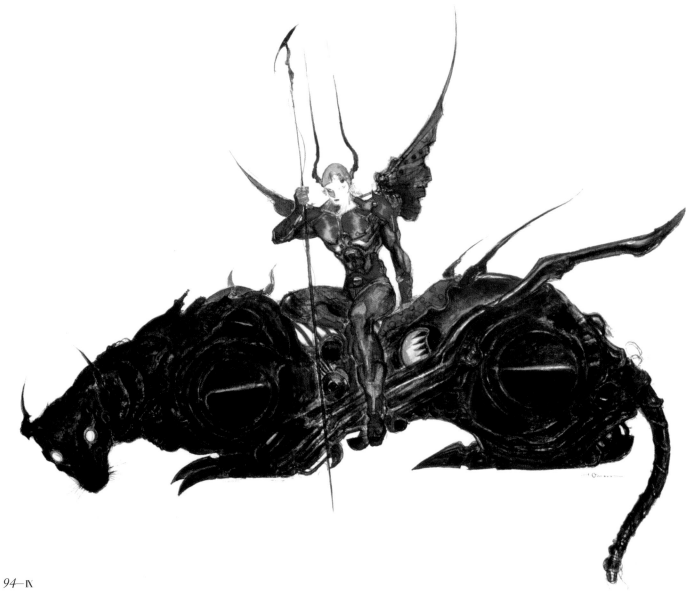

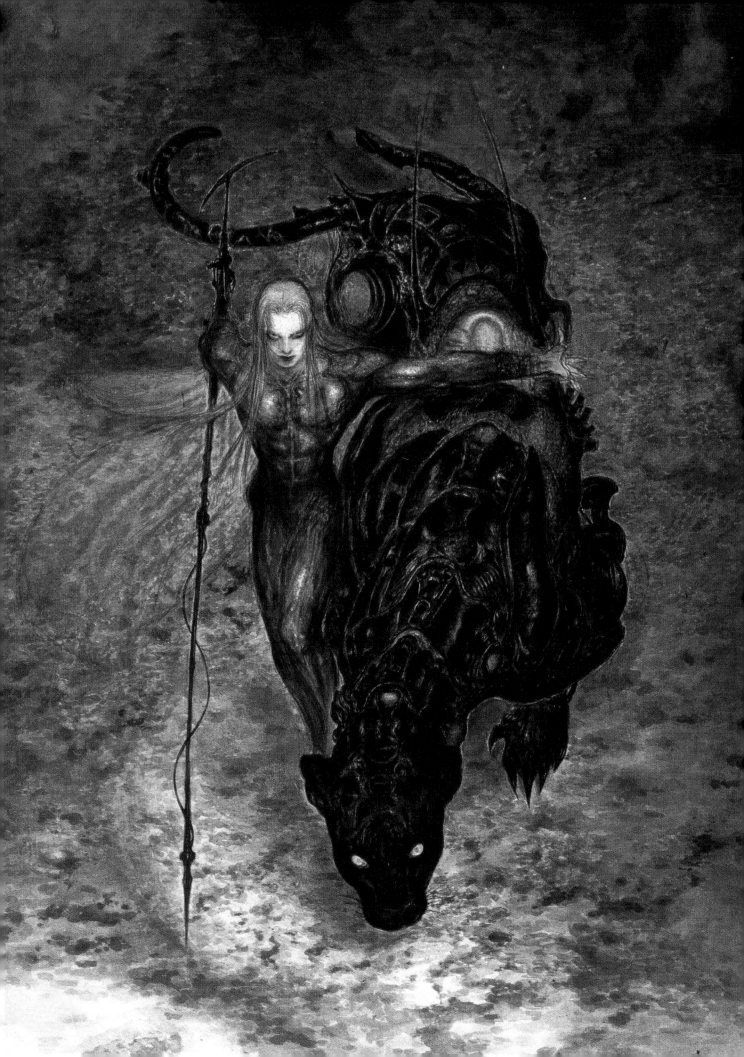

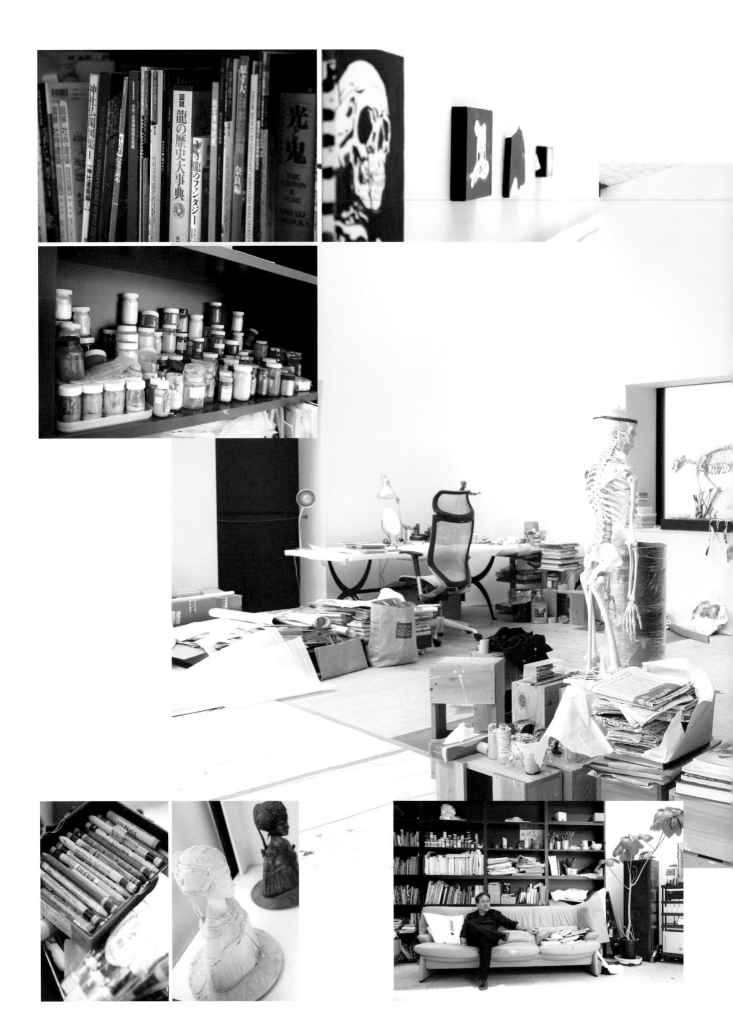

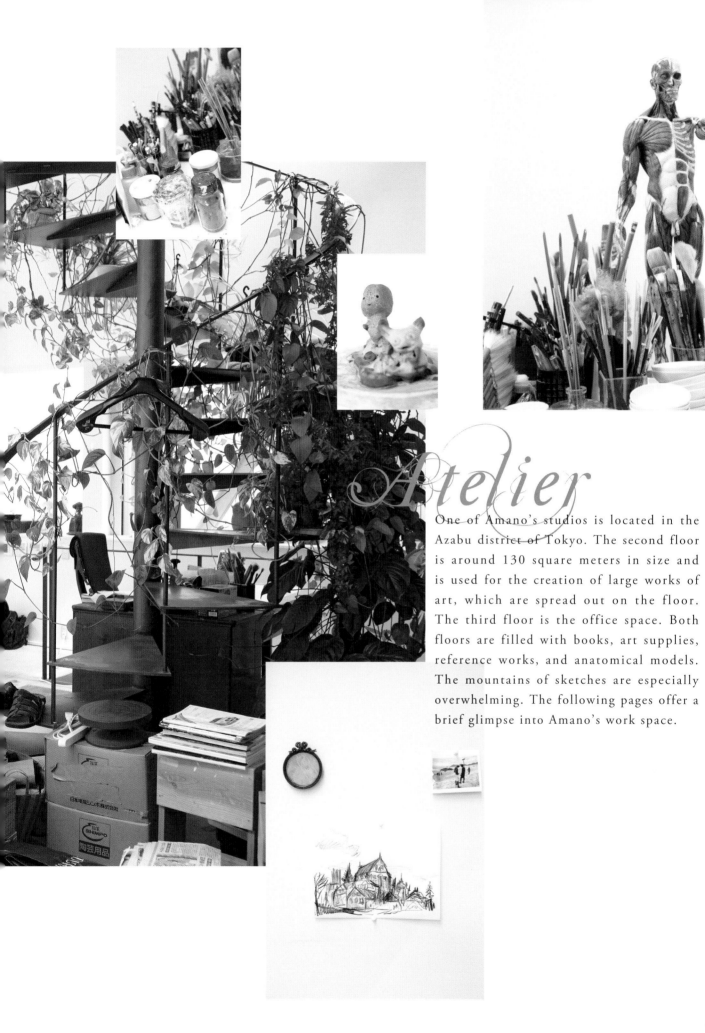

Atelier

One of Amano's studios is located in the Azabu district of Tokyo. The second floor is around 130 square meters in size and is used for the creation of large works of art, which are spread out on the floor. The third floor is the office space. Both floors are filled with books, art supplies, reference works, and anatomical models. The mountains of sketches are especially overwhelming. The following pages offer a brief glimpse into Amano's work space.

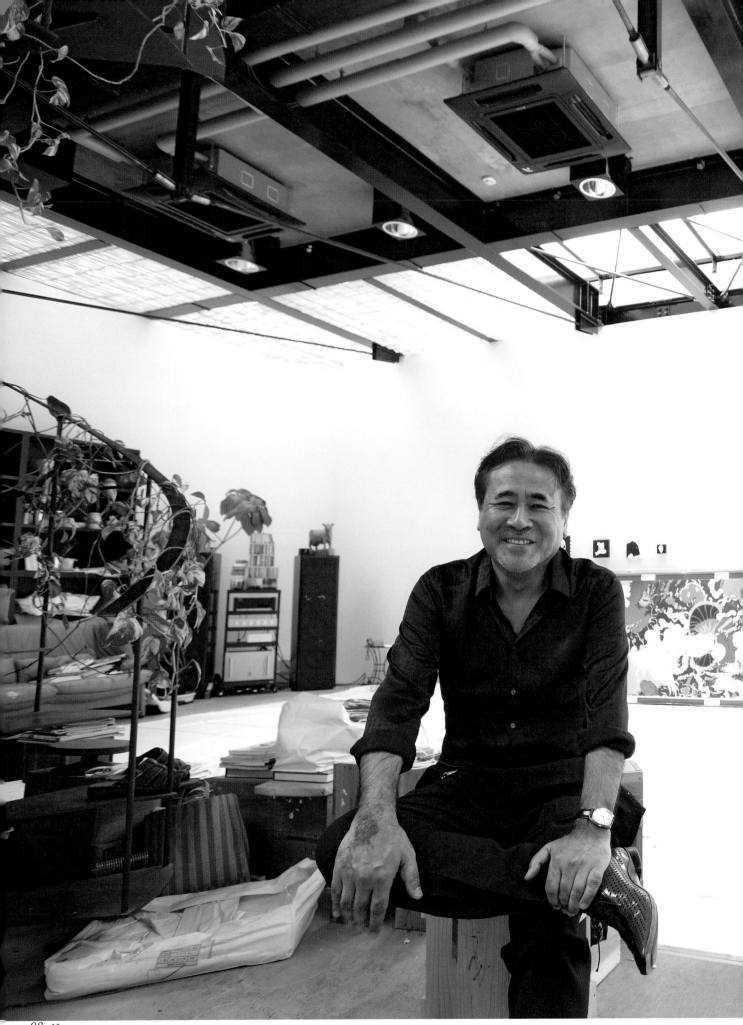

Interview

SURVEYING A MOUNTAIN OF SKETCHES

YOU DRAW SKETCHES WHILE YOU'RE ON HOLIDAY TOO?

I don't do it in a serious manner, but since I can't remember the particulars of a thing when I just take a photo of it, I do sketches to capture what I want to remember. This might be a good idea for young aspiring illustrators, to help them get comfortable with the act of drawing.

Honestly speaking, I don't really want to draw during my down time. But I just don't have anything else to do.

I write little notes above the sketches like "sky" or "yellow" that are meant to be shorthand prompts for me when I color them later. Oh, this is a sketch of waves at the beach in Dubai; their shapes are a bit different from the waves in Japan.

THERE ARE A LOT OF FLOWER SKETCHES HERE TOO.

I used to take photos of flowers and look at them later for reference. But if I make a sketch, the image stays inside my head. Flowers wither away, so I do sketches of a flower before and after it has withered. I once went to see a fetish play with the S&M novelist Oniroku Dan and did live sketches of that too, but I can't show them here [laughs].

*This interview is a revised and edited version of a piece that ran in Issue 195 of *illustration* magazine.

Past

ON ENTERING TATSUNOKO PRODUCTION AT FIFTEEN

LET'S TALK ABOUT YOUR PAST FIRST. COULD YOU GIVE SOME EXAMPLES OF TIMES YOU CONSIDER TO BE TURNING POINTS IN YOUR LIFE?

The odd thing is that my turning points come in fifteen-year cycles. I experienced huge life changes when I was fifteen, thirty, and forty-five years old.

The first is when I was fifteen. I started working for Tatsunoko Production. I lived in Shizuoka Prefecture, but a childhood friend of mine lived in the neighborhood where Tasunoko's studio was in Tokyo, so I drew some illustrations and went to show them. They hired me and I became an animator. I began doing character designs from around age seventeen and began working on *Yatterman* and *Gatchaman* at around twenty.

SO YOU BECAME A PROFESSIONAL ANIMATOR AT FIFTEEN.

If I hadn't had that experience, I wouldn't be where I am now. I never had any formal training in how to draw, but I entered this world of professionals where there's no room for you to be bad at drawing. I managed to make it through that tough situation, and that was the important thing.

WAS THAT AROUND THE TIME WHEN YOU DECIDED TO MAKE A LIVING AS AN ILLUSTRATOR?

I loved to draw, but I was basically confined to the "Character Room," continuously drawing assignments, and that was hard. The deadlines were every week and I had to draw several dozen characters for each deadline. The only thing that I was thinking in my twenties was, "How can I get out of here?" [laughs]

There was even a time when I ran away because I was so overloaded, and the company sent a telegram to my house to bring me back. I was young and single, so I wanted to have more free time to watch movies and enjoy my life. The workload was immense, and I still feel a little traumatized by having gone through that.

YOU WERE WORKING AT TATSUNOKO PRODUCTION AT THE SAME TIME AS KUNIO OKAWARA, RIGHT?

I was working in the Character Room and he was doing mechanical designs in the department that specialized in background art, so we never had much direct contact at work. My immediate boss was Mitsuki Nakamura, who was a mechanical designer like Okawara-san. Yoshiyuki Tomino had the desk next to me, so there were many people there who are still active in their professions.

THE NEXT TURNING POINT CAME WHEN YOU WERE THIRTY?

I had been drawing illustrations as an employee of a corporate organization, and after a while I began to wonder what my own work could be. I began to have the desire to draw my own illustrations rather than create animation. I would take my drawings to a publishing company back then and they'd ask me, "So, which one's your work?" and I thought they had a point.

That was my second turning point, just before I turned thirty. After that, a lot of my work started getting published and I was getting busier with that, so I decided to part from the company.

WHEN WERE YOU THE BUSIEST?

Around the time when I was thirty-four, thirty-six. I was working on the Edogawa Rampo collection and other series as well. That was my busiest time as a professional illustrator. Rampo is so famous that everyone has their own mental image of his work. So sometimes I'd avoid reading the story itself on purpose and would create the cover illustration from the image conveyed to me from the title alone. I had a deadline to meet every day, and there was even a time when I dashed out a piece after I received the phone call saying the editor was on the way to pick it up.

But then things began to get repetitious. Once people recognize a certain illustrator's style, they keep asking for similar kinds of work. You get a lot of jobs and you're satisfied by meeting their needs. Of course you become proficient at what you do because you're doing the same kind of thing over and over, but you also start stagnating. I didn't want to be just a trade artist, and at a certain point I felt I had to get out of that cycle.

I wanted to go back to my drawing roots. I didn't want to get complacent just because I was busy. I was thinking about the

Left: The lithograph workshop in New York.

Right: Amano working on a lithograph.

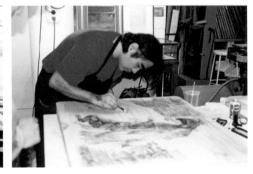

important things in my life beyond just work, and so I wanted to take better care of my relationship with my illustrations.

AND THAT WAS YOUR THIRD TURNING POINT?

I thought that I'd done enough work as a professional illustrator. I wanted to create bigger pieces, so I joined a workshop and began working on lithographs. That was around the time I held my first solo exhibition in New York. So yes, that was my third turning point, when I was forty-five. I felt that if I was going to hold an exhibition over there I needed to be creating there too, so I set up my studio in SoHo.

ON WANTING A CHALLENGE

WHAT LED TO YOUR DECISION TO GO OVERSEAS?

To be honest, I wanted to go a lot earlier. But I was too busy with my work. As for what was behind the decision, the only thing I can say is, I just wanted to go. I met an editor at my solo exhibition in New York in 1997 and got the opportunity to work with that person. I also did some fashion-related work with other people I met. That first exhibition in New York opened new doors for me.

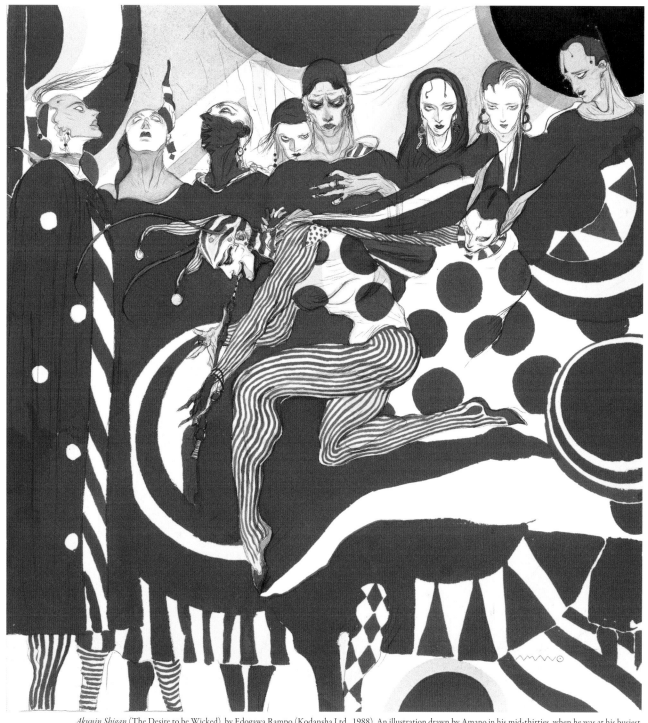

Akunin Shigan (The Desire to be Wicked), by Edogawa Rampo (Kodansha Ltd., 1988). An illustration drawn by Amano in his mid-thirties, when he was at his busiest.

A LOT OF PEOPLE MAKE EXCUSES FOR NOT LEAVING JAPAN BY SAYING THEY'RE TOO BUSY, THEY DON'T SPEAK ENGLISH, AND SO ON.

I can understand that very well. They speak a different language and they have a different culture. I agree that it's hard and sometimes frustrating. I felt like a migrant worker. I've lived overseas at different points, but I don't think I could do it forever. After all, I'm Japanese and I like Japan.

SO WHY DID YOU STILL DECIDE TO GO OVERSEAS?

Speaking in terms of baseball, it was like wanting to challenge myself in the big leagues. I wanted to see how far I could go. If you're going to the United States, who you contact first to go there is very important. There are many different layers in the art world, and it depends on your age when you first go there, but it's very difficult to rise up to the top from the bottom. You need to approach the people who are in the top layers from the start. Those people and their environment are totally different, you see.

SO YOU WANTED TO CHANGE YOUR ENVIRONMENT AND CHANGE YOURSELF?

Yes. This is something I always want to tell young people: no one is going to come along and change you. You have to do it yourself. People ask you to do a lot of work for them and just when you're at your peak, you try to do something different and everyone objects. You need to have a strong determination about what you really want to achieve. No one understands you better than yourself. Don't let other people sweep you along. Make your own decisions.

Present

ON CREATING NEW WORLDS

YOU OFTEN TALK ABOUT HAVING A STRONG INTEREST IN MYTHOLOGY.

Yes. I think a lot about how I would depict my own mythological world. I'm currently trying to make that into a movie. I've worked on illustrations, paintings, video games, print publications, theatrical plays…all sorts of different things. If you think of each one of these as a separate morsel, then "mythology" is the skewer that holds them together.

Could you explain what you mean by "mythology" in simpler terms?

A dream world. Surreal. Irrational. Like Greek mythology, for example. It may seem like an absurd thing to us today, but the people back then may have seriously believed in it.

I want to create a modern-day mythology that I can believe in. I want to create something irrational using state-of-the-art knowledge. *Star Wars* and other sci-fi works are very serious modern-day mythologies of a sort. I want to create something no one has created before.

Are there any other creative areas that interest you right now?

Painting pottery. It's very fun. I feel that the ceramic pieces are an empty canvas for me. I've been doing it since 1999 thanks to a potter who I'm acquainted with in Kyoto. We did a collaboration between a traditional Japanese restaurant in Kyoto and a French restaurant in Tokyo. If you're associating just with other illustrators or just with other potters, things can get boring. It's a lot more interesting when people from different fields get together to inspire each other to create something.

Aside from drawing, is there any other hobby that influences your creative work?

I'm not too fond of collecting things. Oh, but I love looking at art supplies. For example, new ballpoint pens keep coming out, so I'll drop by the art supply store Sekaido to browse them, and if something interests me I'll buy it. I like books too, so when I go overseas I buy a lot of heavy art books and carry them back with me.

I always listen to music when I'm drawing but I don't have a specific genre I'm loyal to. Listening to music helps me move my hand unconsciously. The flow of time soothes my mind. And depending on what I'm working on, sometimes I'll turn on the TV and watch some shows too.

Doesn't it disturb your concentration?

No, it's good because it stops me from thinking too hard about what I'm doing. And my productive concentration period isn't that long. About fifteen minutes, I think. If I went longer than that, thirty minutes or so, I'd start to get fatigued.

ON INSPIRATION
FROM DIFFERENT
ENVIRONMENTS

I CAN SEE FROM LOOKING AROUND THIS
ROOM THAT YOU DO A LOT OF ROUGH
DRAFTS.

I draw around an average of twenty to thirty rough
drafts per completed illustration. The drafts just keep
increasing. I can draw them endlessly because each
time I can change another element, the posture of
the character or whatever. The fifth draft will always
be better than the first one, and the tenth one better
than the fifth, and so on. But it's also important to
know when to stop, when you've got it just right.

When I start a new work I'm thinking about it rationally at the
beginning. But once I'm in it and engaged, I begin to draw at an
unconscious level. It's like playing sports.

DO YOU HAVE OTHER STUDIOS BESIDES THIS ONE?

I can't work on very large pieces here, so I go to a studio that's
about 330 square meters and located in the suburbs. I work with
an assistant there.

I have another studio in Paris where I usually work alone when
I'm there to visit art galleries and bookstores. I have drawn and
stored a lot of rough sketches of my original work there. I travel a
lot, actually. Maybe I can't work in one place.

IS TRAVELING IMPORTANT TO YOU?

Different locations are important. I go somewhere overseas and
the culture is different. I go outside and the people look different.
I'm immersed in a different environment. The creative stimulation
from that affects my work.

WHO ARE THE ARTISTS YOU WERE INSPIRED BY?

I love Disney. I especially like the animated movies that were
drawn with dark, solid lines like *The Sword in the Stone* and
The Jungle Book. I often tried to create the same effect with the
characters I designed.

When I decided to become an illustrator, I looked at a lot of
works by different artists and copied them. And when I thought
about which of the artists' works I truly liked, I realized they were
mainly in the art nouveau style: Mucha, Munch, Moreau... I can't
narrow it down to just one person. One thing they all have in
common is that they create surreal works.

AN ARTIST LIKE TURNER TRIED TO CAPTURE
MOVEMENT INSIDE A SINGLE PANTING. WHEN YOU HAVE
AN IMAGE IN YOUR HEAD, IS IT STILL OR MOVING?

It's more like recorded footage. And when I want to create an
illustration from it, I take a photograph of it to clip out that
very instant…or something like that. But I like Turner too. I can

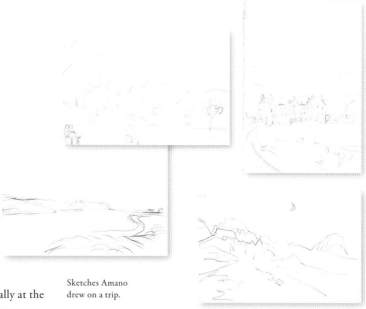

Sketches Amano
drew on a trip.

experience and identify with his work. I like Monet as well, but
I have to step into the world he created to enjoy his work. With
Turner, the colors of his paintings are unique. They're not just the
colors of paint—he's actually trying to draw out the various colors
that make up natural light, what makes nature so beautiful.

SO HE TOOK A REALISTIC APPROACH WITH HIS WORK
VIA THAT METHOD.

Yes. He depicts nature in the totally opposite way from me. But
maybe I need to go in his direction with my art in the future.

Future

ON REFINING ONE'S WORK

CAN YOU TALK A LITTLE BIT ABOUT WHAT YOU WANT
TO DO IN THE FUTURE?

From now on, I will probably need to cut back on or eliminate
anything that's not essential. Then I can concentrate on what's left
after that, on the things I'm interested in and that make me think,
"This is good."

BY THAT, DO YOU MEAN YOU'RE GOING TO MOVE AWAY
FROM COMMERCIAL ILLUSTRATION TO DO MORE FINE
ART PIECES?

I guess another way to say it is that I want to learn about more
things. I want to learn more and use that knowledge. I want to
improve the quality of my work, of course, but I also want to
create something that has never been created before. Something
that will touch peoples' hearts.

Until now, I was drawing only for myself, but I'm currently
thinking deeply about what I need to do from here. Or rather, I
started doing that about three years ago. And I want everybody
around the world to see the result, not just people in Japan.

SO YOU'RE LOOKING FOR AN INTERNATIONAL AUDIENCE?

Yes. There's no other choice. We live in an era when we have access to so much information. We aren't confined to one place anymore. It doesn't matter if we live in Japan or Tokyo or Aomori Prefecture or wherever else. Whether you're an athlete or an artist or something else, it's only natural to aim for the world.

For now, I want to create something big. I want to challenge myself to create large works of art for an exhibition. In the past, I could make cool things by copying something that did not exist in Japan yet, but originality is more important now. Depicting what I have inside me is a global approach.

NOTHING IS WASTED

ON A BASIC LEVEL, WHAT DOES MAKING YOUR OWN ART MEAN TO YOU?

Well, first I'd need to think about what "my art" is. In some sense, the designs I had been creating for the animation production company were nevertheless my own work too, no different from what I'm creating now. They came out of me, so by definition they were an expression of my individuality. I realized that only after I'd quit the company to make a living by my own illustrations.

Now that I think of it, nothing was wasted. As a matter of fact, the things you have to do and the effort you have to make in a corporate organization are very important. You'll never improve if you draw only what you like. I was forced to draw things I wasn't good at and that trained me.

YOU BEGAN WORKING AS A PROFESSIONAL FROM THE AGE OF FIFTEEN, BUT WHEN WERE YOU CONVINCED THAT YOU HAD FOUND YOUR OWN STYLE?

When I was around thirty. I drew a certain person and thought, "Hey, this is good. I've never seen anything like it before and it's got me written all over it." And that wasn't the only illustration I felt that way about. I got that feeling from all the illustrations I drew during that time.

The way I drew faces and the little visual habits that I had. I looked at my own work and had the feeling that I usually got from looking at other people's work. That was something I had never experienced before.

COULD YOU TELL ME YOUR THOUGHTS ON COLORS AND LINES?

I like them both. Colors are very intuitive, I think. I feel happy when I'm coloring my illustrations. For example, if I'm working with red, I end up with an emotion conveyed by that color.

You need skill with linework, though. If you're drawing a man or a woman, you'll need to change the nature of the lines depending on the individual. The image in your head comes to life for the first time when you do the lines. They're what make two-dimensional objects seem three-dimensional. I tend to be attracted to works with strong lines.

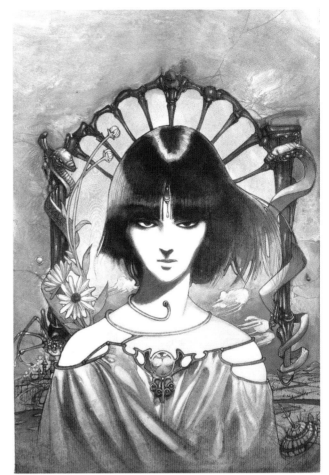

The Spider of Karon (1983). One of the works that helped Amano refine his art style.

STICK WITH WHAT YOU LIKE

ONE LAST QUESTION. IT'S BEEN A LONG JOURNEY FOR YOU UP UNTIL NOW, SO AT THIS VANTAGE POINT IN YOUR CAREER, WHAT WOULD YOU SAY DRAWING MEANS TO YOU?

Drawing is the only thing I can do. Other than eating or sleeping, the easiest thing for me to do is to draw.

An art student at an overseas interview asked me the question, "Could you give me three things that are important in creating illustrations?" My answer was, "I have only one: it's whether you like to draw or not." I think "like" is the key here. If you like it, you can do it for the rest of your life.

The important thing is if you are willing to spend your whole life at it. If you truly like doing something, then you should be able to keep with it to the very end. If people say negative things to you and you give up and quit, then it means that you didn't really like it after all. This isn't a groundbreaking observation, but if you enjoy doing something, you should stick with it.

If you truly like what you're doing, I believe you can pour every minute of your life into it. If you like it to the point where you can say, "Drawing is everything to me and I don't care about anything else," then you will definitely succeed. Even if you're not that talented, you can still do something as long as you have that passion. Talent is just an individual trait. You need effort to capture it.

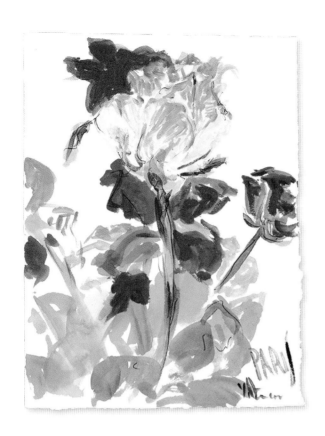

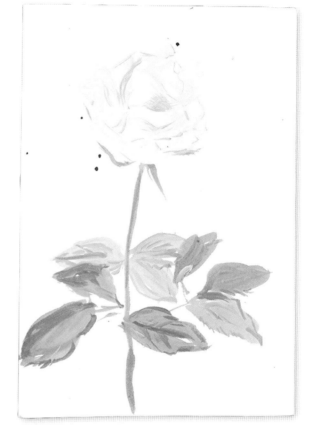

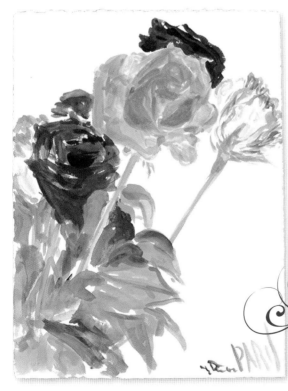

Sketches of
Flowers

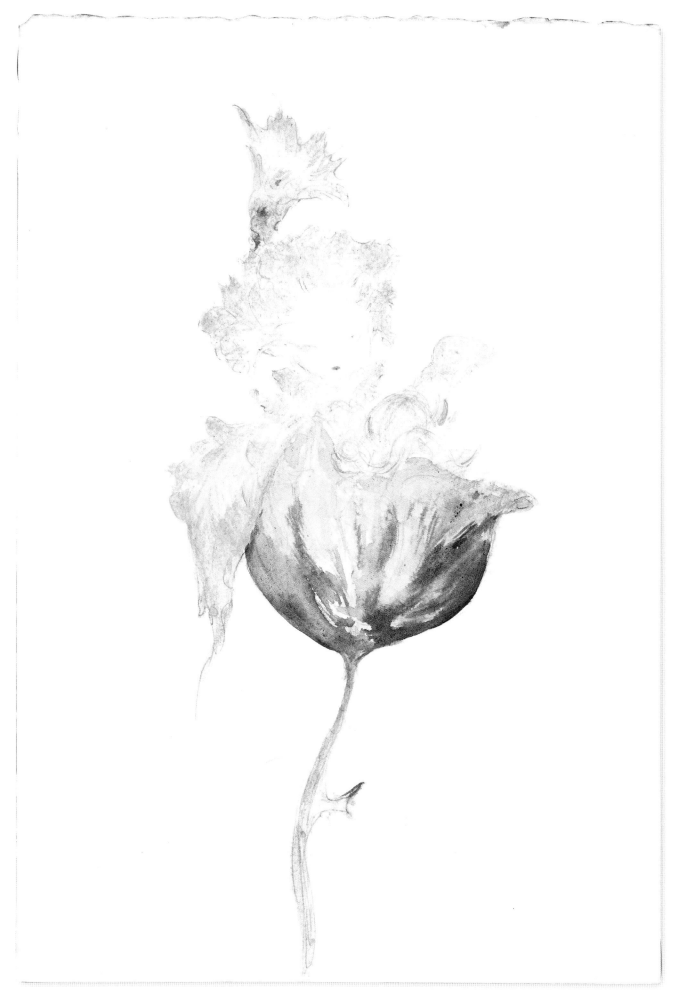

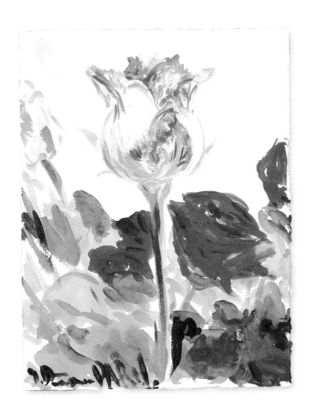

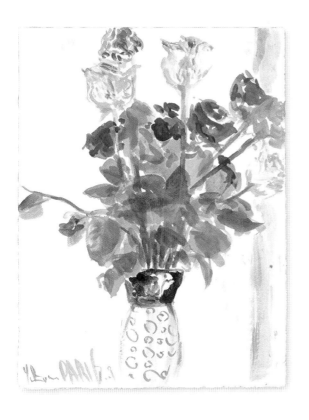

"Colors convey a lot of emotion. They add depth to a piece." Amano doesn't know yet what the illustration will look like when it's done.

He's using Turner Big Art Color, a professional watercolor paint, but dilutes it heavily with water.

How to Draw

In addition to the creation processes covered earlier, we asked Amano to make some new pieces for us. Rather than a detailed, step-by-step explanation of the process, the photo sequences here are meant to convey a sense of his drawing speed and skill.

The brush he's using is a *Kurojiku Itachi Choho Menso Dai* (Black-Handled Weasel-Hair Long Brush for Doll Faces, Large Size). Sometimes he uses a special calligraphy brush he bought in Kyoto.

For more monochrome illustrations, he puts down solid layers of color without any tonal gradations.

Drawing a male character from a video game. He uses a dip pen because it is easier to adjust the thickness of the lines with it.

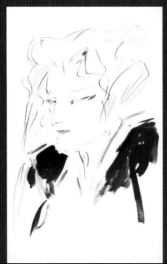

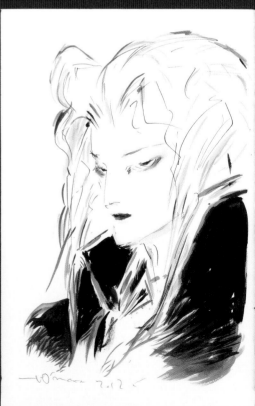

The first illustration is complete.

He quickly moves on to the second piece. He uses a pencil to draw the lines since it is easy to vary dark and light lines with the use of pressure.

"Cute, isn't she? I always go with red for her," he says as he colors a female character.

He is so fast that small droplets of paint are dripping off his brush but he doesn't mind. He keeps painting quickly.

He already has set colors to use for each character, so he does not hesitate when selecting the paints.

He doesn't mind even if a different color falls into the paint mixing dish, muddying the hue a bit. He continues to paint the illustration.

The dip pen reappears. Female characters have a lot of curves and he focuses on drawing gentle lines for them.

He uses a gold pencil to add some shading. He likes gentle gold tones and often uses them without worrying about how they may turn out when the illustration is printed.

The tools used for this piece: paint, pen, and pencil.

He adds a minor character in the bottom right corner. This character often appears in his autographs.

He draws the jewelry using a gold oil-based pen. "The red and gold look pretty, don't they?"

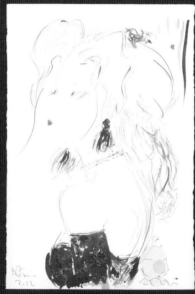

The second illustration is complete.

"I've got paint here too, so..." He begins work on another piece.

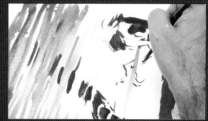

"I have to make this into an illustration somehow." He begins to draw a black dragon. He follows his instincts.

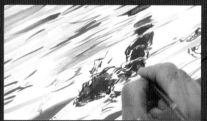

"I think the neon lights at night look like this. I'm going to make the paper dirty, so I might as well enjoy it."

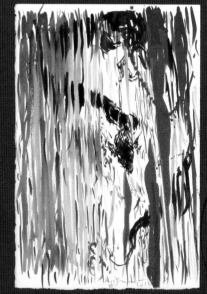

The third illustration is complete.

DRAWING VEGETABLE FAIRIES

For the fourth illustration, he decides to use the pastel crayons he happened to be using for another piece. We asked him to draw a vegetable fairy character he had created.

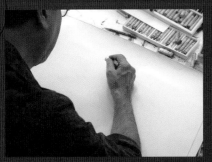

He chooses to draw on *washi* handmade paper, which is his preference these days.

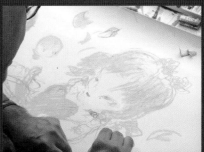

Crumbs are falling off the pastels as he colors the illustration, but he doesn't mind.

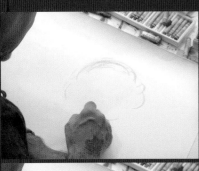

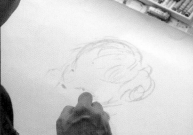

"It's fun to draw like this because it makes me feel like I'm a child again."

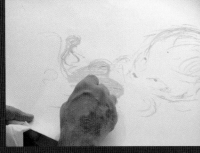

He normally doesn't use pastel crayons. "I like using drawing tools that I'm not familiar with. Because the less familiar I am with something, the harder I have to try."

"I like the blurriness you get when you use the pastels on top of each other."

"I'd decided from the start to use blue for the background. Since I was going to draw flowers, I wanted the colors to balance out."

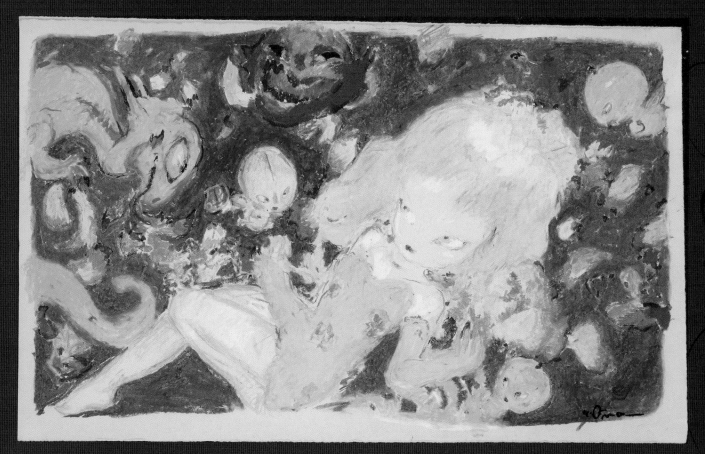

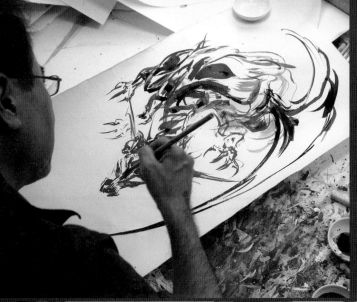

DRAWING BAHAMUT

"Cute characters are fun, but scary things are fun to draw too." So Amano proposed to draw the mythical dragon Bahamut.

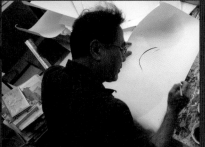

He's using India ink and a brush to draw flowing brushstrokes upon *washi* paper.

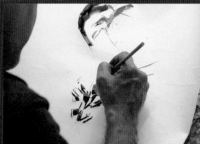

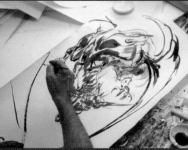

The wings are drawn swiftly with some of the India ink spattering across the page.

He starts with the neck.

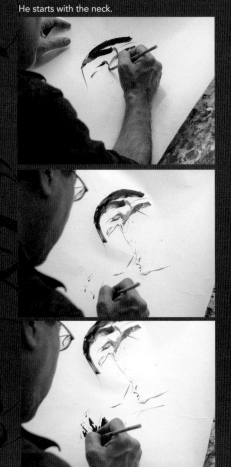

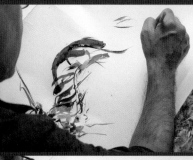

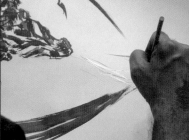

"You can add a metallic glint to the ink by mixing some silver into it."

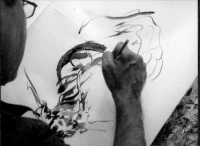

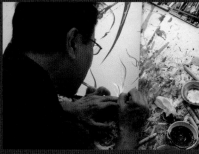

He signs his name to complete the illustration.

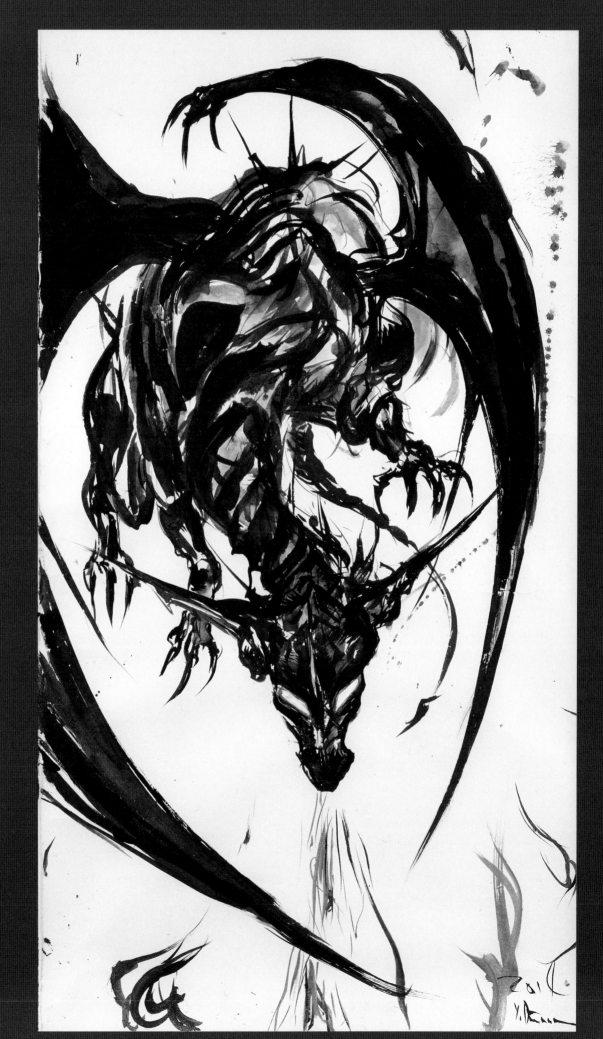

Other Sketches

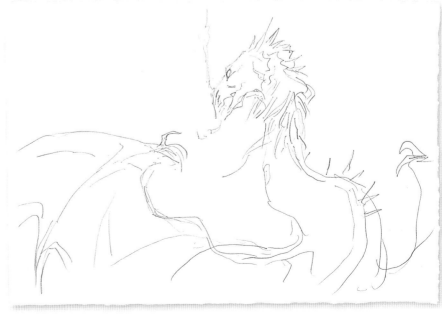

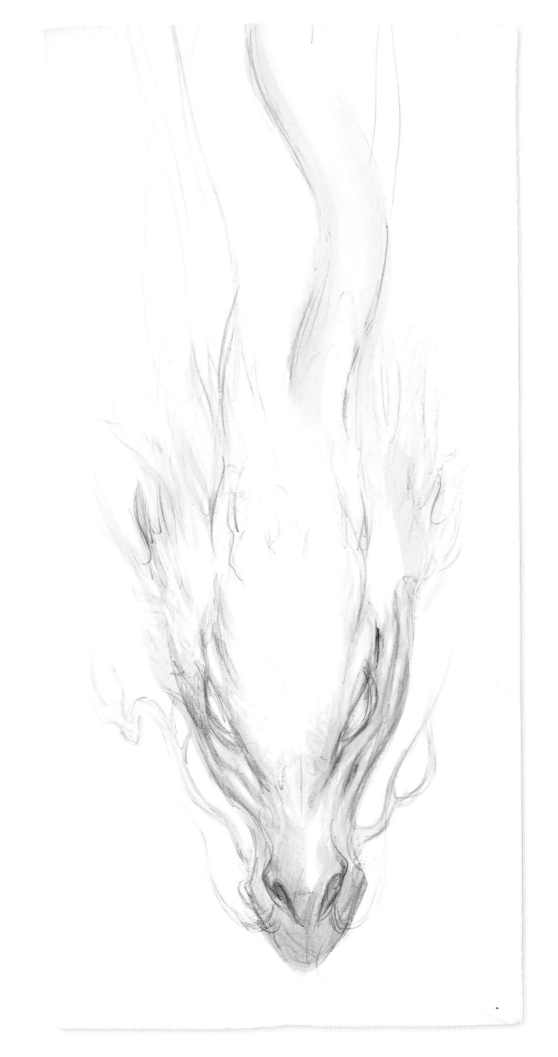

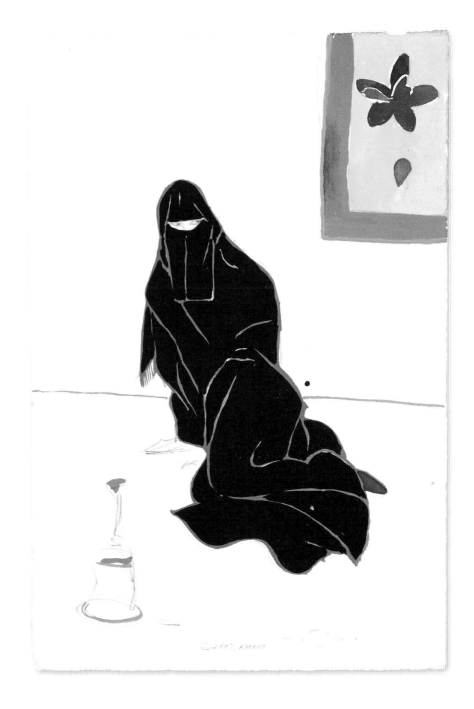

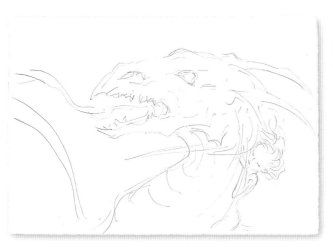

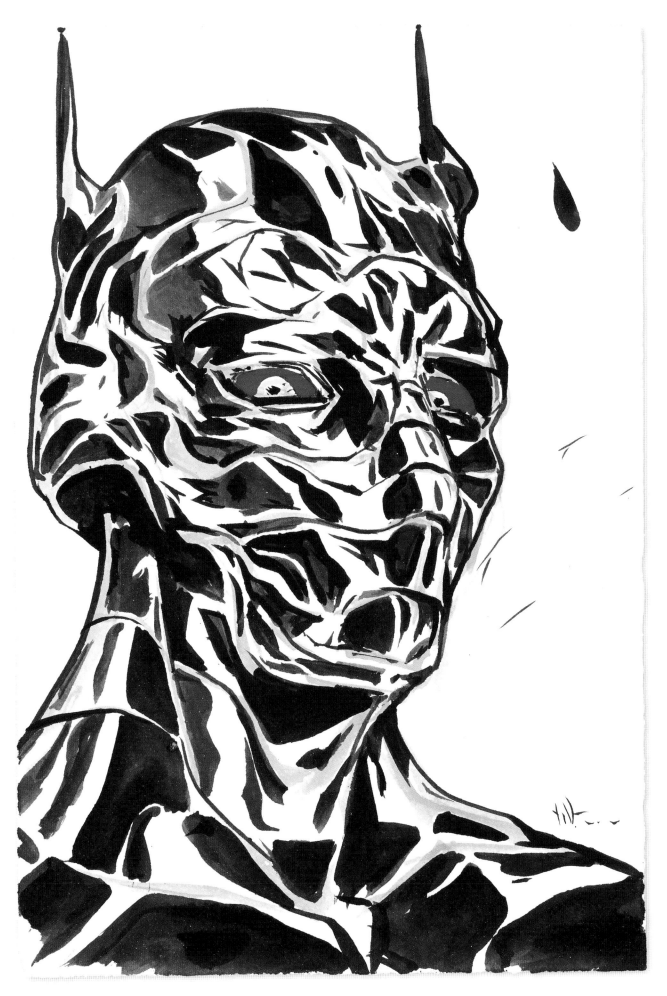

121

Chronology

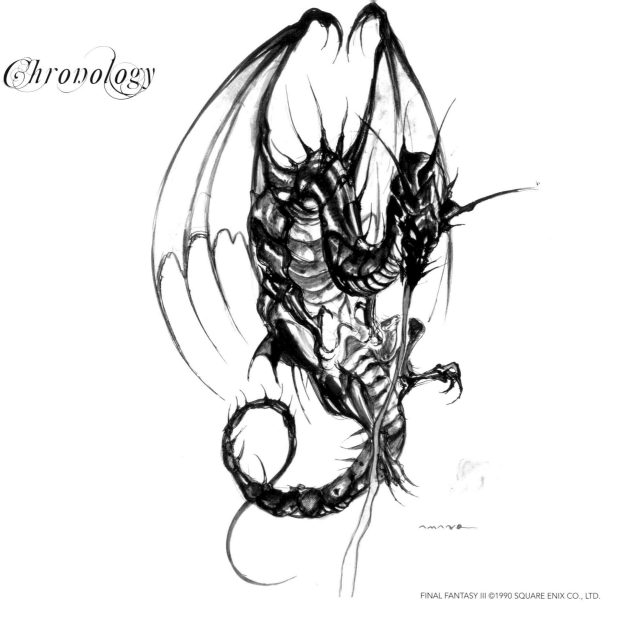

FINAL FANTASY III ©1990 SQUARE ENIX CO., LTD.

1952

Born in Shizuoka Prefecture.

1967

Joins Tatsunoko Production (now Tatsunoko Pro). Works on the character designs for *Science Ninja Team Gatchaman*, *Honeybee Hutch*, *Time Bokan*, and many other series.

1981

Amano's series of illustrations *Twilight World* published in *SF Magazine* (Hayakawa Publishing, Inc.).

1982

Leaves Tatsunoko Production. Creates cover and interior illustrations for the *Chimera Ko* series, by Baku Yumemakura.

1983

Receives the 14th Seiun Award (granted by the Japan Science Fiction Convention). Continues to win the award for four years in a row, until the 17th Seiun Award. Creates the cover and interior illustrations for *Vampire Hunter D* series, by Hideyuki Kikuchi (Asahi Sonorama).

1984

First art book, *Maten*, is published (Asahi Sonorama). Invited as a guest to the World Science Fiction Convention in Seattle. Creates the cover and interior illustrations for the *Elric Saga* series, by Michael Moorcock (Hayakawa Publishing, Inc.)

1985

Creates original story and does art direction for the animated movie *Angel's Egg*, directed by Mamoru Oshii. Accompanying art book *Shojoki: Angel's Egg* is published (Tokuma Shoten). Creates the cover and interior illustrations for *The Guin Saga* series, by Kaoru Kurimoto (Hayakawa Publishing, Inc.).

1986

Art book *Castle of Illusions* is published (Shinshokan). Creates the cover illustration for the magazine *Shishioh* (Asahi Sonorama). Creates the cover and interior illustrations for *The Heroic Legend of Arslan* series, by Yoshiki Tanaka (Kadokawa Shoten Co., Ltd.).

1987

Works on the character and visual concept design for the video game *Final Fantasy* (Square Enix). Art book *Imagine* (Shinshokan) is published. Creates the cover and book illustrations for *Sohryuden: Legend of the Dragon Kings*, by Yoshiki Tanaka (Kodansha Ltd.).

1988

Works on visual concept design for *Final Fantasy II* (Square Enix).

1989

Art book *Hiten* (Asahi Sonorama) is published.

1990

Works on stage design for *Nayotake* (Nissay Theatre), directed by Tamasaburo Bando. Works on visual concept design for *Final Fantasy III* (Square Enix).

1991

Works on the stage design for *Ajisai* at the World Ballet Festival. *Tarot Card Art Book* (Kofusha Publishing), *Tenma no Yume* (Kadokawa Shoten Co., Ltd.), and *Dawn* (NTT Publishing) art books are published. Creates illustrations for the movie *Heaven and Earth*. Works on visual concept design for *Final Fantasy IV* (Square Enix).

1992

Rasenoh, co-written by Baku Yumemakura (Tokuma Shoten) and *Tsuki no Oh* (Nami Shobo) art books are published. The cover designs of the Japanese edition of *Elric Saga* by Michael Moorcock are adopted for use on the UK editions. Works on visual concept design for *Final Fantasy V* (Square Enix).

1993

Creates the stained glass design for the Kimie Imura Fairy Art Museum in Kanayama City, Fukushima Prefecture. *Mono: Heroes of Illusions* (Anzudo), a collection of monochrome illustrations, and *Tengoku e no Kaidan*, a collection of lithograph works, written by Takashi Matsumoto (Kodansha Ltd.), are published. Video disc *Yoshitaka Amano: Karei naru Gensobi no Sekai* (Polydor) is released.

1994

Works on stage and costume designs for *The Sea God's Villa* (Saison Theater). *JAPAN* (NTT Publishing) and *Katen* (Kodansha Ltd.) art books are published. Works on visual concept design for *Final Fantasy VI* (Square Enix).

1995

Begins work on lithographs at the Atelier Maeght in Paris. *Front Mission: in Huffman*, written by Kow Yokoyama (NTT Publishing), *Yoshitaka Amano* (Art Vivant Co., Ltd.), and *Celt Fantasy*, written by Kimie Imura (Anzudo) are published. Works on character and visual concept designs for the video game *Front Mission* (Square Enix).

1996

Begins working on lithographs at Solo Press in New York. Works on stage design for *Yang Guifei* (Kabuki Theater). Works on visual design for JUDY & MARY's music video, *Classic*. *Guin Saga Art Book* (Hayakawa Publishing, Inc.), *One Thousand and One Nights: Grape Princess*, written by Takashi Matsumoto (Kodansha Ltd.), *Fairies* (Anzudo), and *Gensokyoku: A fantasia* (Art Vivant Co., Ltd.) are published. Works on character and visual concept designs for the video game *Gun Hazard* (Square Enix).

1997

Sets up studio in SoHo, New York. Creates character design for Fuji Television's Pink Dolphin Project mascot, Pinka. Works on stage and costume designs of *Les Chérubin* for the Takarazuka Revue, Snow Troupe. Works on the stage design for JUDY & MARY's tour, *The Power Sauce Delivery*. *Coffin*, a collection of art from *Vampire Hunter D* series, and *Tale of Genji* (Anzudo) art books are published. Works on visual concept design for *Final Fantasy VII* (Square Enix).

1998

Supervises and works on concept of symphonic project *1001 Nights* and presents it at the *1001 Nights* Los Angeles Philharmonic concert. Works on poster for *The Sandman: 10th Anniversary* (DC Comics). Designs bronze fairy statue for Mokurei Bridge, Kanayama City, Fukushima Prefecture. Works on character and visual concept designs for the video game *REBUS* (Atlas).

1999

Creates stained glass piece for the Kimie Imura Fairy Art Museum in Utsunomiya City, Tochigi Prefecture. *1001 Nights* is released at movie theaters in Japan (produced and distributed by Bell System 24). *Alice Erotica*, written by Hiroshi Unno (Anzudo), *The Sandman: The Dream Hunters*, written by Neil Gaiman (DC Comics), and art book *Biten* (Asahi Sonorama) are published. Works on visual concept design for *Final Fantasy VIII* (Square Enix).

2000

Invited to Dragon Con in Atlanta and receives the Dragon Con Award and Julie Award. *The Sandman: The Dream Hunters* nominated for Hugo Award, receives Eisner Award. Spanish edition of *The Sandman: The Dream Hunters* and the Japanese edition (Inter Books) are published. *Märchen* (Anzudo) and *Vampire Hunter D* (Asahi Sonorama) art books are published. Works on character and visual concept designs for the video game *El Dorado Gate* (Capcom). Works on visual concept design for *Final Fantasy IX* (Square Enix).

2001

Creates posters for *Batman* and *Superman* (DC Comics). Creates character "Kotatsu" used for Kodansha Bunko 30th Anniversary campaign. Creates poster for the opera *Così fan tutte*, produced by Ken Nishikiori. *POEM*, co-written by Madoka Mayuzumi (Anzudo), *The Magic Flute* (Asahi Sonorama), *Yoshitaka Amano Art Book: The Sky* (DigiCube), *Elektra and Wolverine: The Redeemer,* written by Greg Rucka (Marvel Comics), *Kotatsu and Friend, Kotatsu's Week* (Kodansha Ltd.), and *The Sandman: The Dream Hunters* (Brazil edition) are published. Works on visual concept design for the movie *Onmyoji*, original story by Baku Yumemakura (Toho). Works on visual concept design for *Final Fantasy X* (Square Enix).

2002

Works are exhibited at fine arts gallery overseas. *The Complete Prints of Yoshitaka Amano* (Bijutsu Shuppan-sha), *Symphony* (Anzudo), *N.Y. Salad* (Yoshitaka Amano Office / SHUFUNOTOMO Co., Ltd.), and *Yoshitaka Amano* (Leo Koenig Inc.) are published. Works on visual concept design for *Final Fantasy XI* (Square Enix).

2003

Creates poster for opera *The Barber of Seville*, produced by Ken Nishikiori. Works on the visual concept design of the movie *Onmyoji II*, original story by Baku Yumemakura (Toho). *AMANO FIRST* (Asahi Sonorama) and *Sumie no Sekai* (Bijutsu Shuppan-sha) are published. Works on visual concept designs for the video games *Front Mission First* and *Final Fantasy X-2* (Square Enix).

2004

Invited as a guest to Imagika 2004. Amano's collaboration with David Bowie, Iman, and Neil Gaiman is published in *V-Magazine* (Visionare). Creates poster for Takarazuka Revue, *TAKARAZUKA Maimu!* Draws poster for the French edition DVD of *Zatoichi* (Wild Side Video). Creates cover and interior illustrations for *Lion Boy,* by Zisou Corder (PHP Publishing). *Silence* (Square Enix), *Concept Design of Onmyoji* (Fujimi Shobo Co., Ltd.), *The Virgin* (GENEON), and *BATTY & BATTINA* (Gentosha Comics) are published. *Les mondes d'AMANO* (Soleil Productions) published in France.

2005

Invited as a guest to Anizona. Works on poster for *Flower and Snake 2 Paris / Shizuko*, by Oniroku Dan (Toei). *Yang Guifei*, written by Baku Yumemakura, is serialized in *Weekly ASCII* (ASCII Media Works). *Flower and Snake* (Ohta Books) and *N.Y. Salad: Sleeping Princess Lettuce* (SHUFUNOTOMO Co., Ltd.) are published. Creates illustration for the video game *Front Mission Online*.

2006

Kitan Soshi, written by Baku Yumemakura (Asashi Shimbun Shuppan) and *Yang Guifei*, written by Baku Yumemakura (Enterbrain) are published. Works on visual concept design for *Final Fantasy XII* (Square Enix).

2007

Directs the seventh night of the movie project *Ten Nights of Dreams*. Receives 38th Seiun Award. Solo exhibition at Nosbaum & Reding (Luxembourg).

2008

Bird's Song DVD (Toei Animation) released. *The Curious Brussel Sprouts* (PHP Publishing) published. Solo exhibitions at Galarie Michael Janssen (Germany) and Art Statements (Hong Kong).

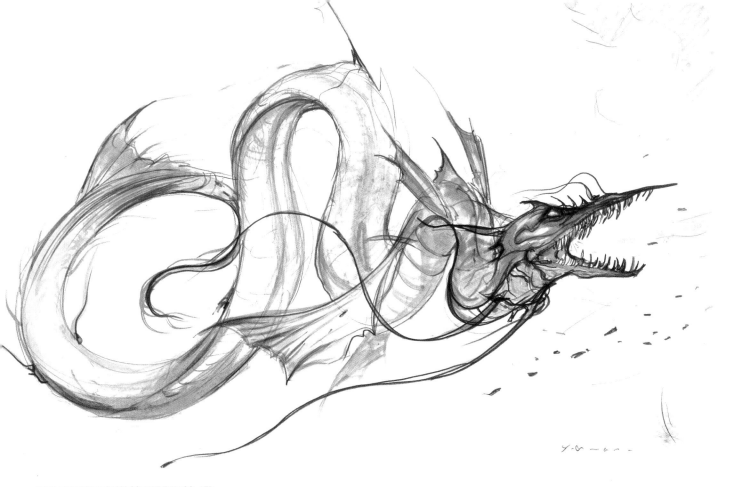

FINAL FANTASY III ©1990 SQUARE ENIX CO., LTD.

2009

Dawn: The Worlds of Final Fantasy (Dark Horse Comics) published. Exhibition "eve" at the Paris Opera House. Solo exhibitions at Metaphysical Gallery (Taiwan), Taipei Modern Art Museum (Taiwan), New People Gallery (San Francisco), and Art Statements (Hong Kong). Works on visual concept design for *Final Fantasy XIII* (Square Enix).

2010

Exhibition "eve" at Kiyomizu Temple, Kyoto. Solo exhibitions at Art Statements (Tokyo) and Nosbaum & Reding (Luxembourg). Works on visual concept design for *Final Fantasy XIV* (Square Enix).

2011

Creates cover for BUMP OF CHICKEN's single CD and DVD *Zero* (limited edition).

2012

Yoshitaka Amano: Rampo Illusion Art (Fukkan dot com) is published. Solo exhibition at Art Statements (Hong Kong).

2013

"Yoshitaka Amano x HYDE Exhibition Fate and Corruption" is held in Tokyo. *Angel's Egg Storyboard Collection*, written by Mamoru Oshii and illustrated by Amano) is published. Solo exhibition "TOKYO SYNC" at the Mizuma Art Gallery in Ichigaya.

2014

Works on cover of Sayuri Ishikawa's album *X-Cross II*. Solo exhibition at the Contemporary Art Museum of Kumamoto.

YOSHITAKA AMANO

Born in Shizuoka Prefecture in 1952, Amano began working at age fifteen for the landmark animation studio Tatsunoko Production, creating character designs. He became a freelance artist after that and received the Seiun Award for four years in a row, from 1983–1986, for his illustration work. He began producing lithographs in Paris in 1995 and in New York in 1999, and held large exhibitions in New York in 1997 and 1999. In 1999 he published *The Sandman: The Dream Hunters* with writer Neil Gaiman, which received a Bram Stoker Award. He is also the recipient of Eisner, Dragon Con, and Julie Awards.

YOSHITAKA AMANO: ILLUSTRATIONS
By Yoshitaka Amano
VIZ Media Edition

Translation & Adaptation – Tetsuichiro Miyaki
Cover & Graphic Design – Fawn Lau
Editor – Leyla Aker

Yoshitaka Amano Illustrations
© 2016 Yoshitaka Amano
© 2016 Genkosha Co., Ltd.
All rights reserved.
Originally published in Japan by GENKOSHA Co., Ltd.
English translation rights arranged with GENKOSHA Co., Ltd. through Dai Nippon Printing Co., Ltd.

Printed in Japan

1 0 9 8 7 6 5 4 3 2
First printing, August 2016
Second printing, July 2024

Published by VIZ Media, LLC
P.O. Box 77010
San Francisco, CA 94107

Jacket Illustration: FINAL FANTASY XI ©2002–2014 SQUARE ENIX CO., LTD. All Rights Reserved.
Cover Illustration: FINAL FANTASY XII ©2006 SQUARE ENIX CO., LTD. All Rights Reserved.